WORKS ON PAPER
FROM FIVE CENTURIES
1300-1800

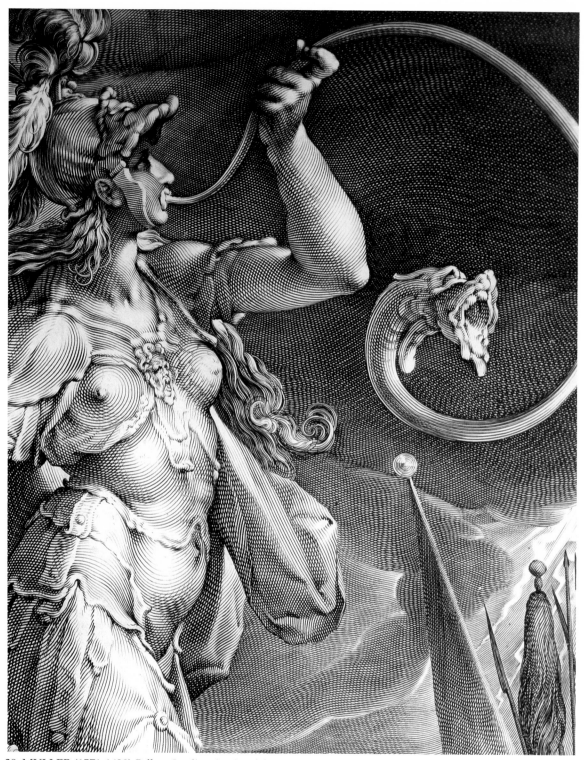

39. MULLER (1571-1628) *Bellona Leading Armies of the Emperor Against the Turks*, engraving, 1600 (detail)

R.S. JOHNSON FINE ART • 645 N. MICHIGAN AVENUE
CHICAGO, ILLINOIS 60611 • (312) 943-1661

WORKS ON PAPER
FROM FIVE CENTURIES
1300-1800

April 1995

ISBN 0-9628903-8-3
Library of Congress Catalogue Card No. 95-67359
Text copyright by R. Stanley Johnson
Printed by Ries Graphics, U.S.A.
Published: March, 1995

Acknowledgment
to those who have been of particular
help in the preparation of this catalogue

Anselmo Carini
*
Martha J. Call Lisa A. Datum

James Van Linden

On Cover
8. GIOVANNI BATTISTA FRANCO (1498-1561)
The Archers (after Michelangelo), about 1540
Pen and brown ink with wash
223 x 290 mm.; 8 7/8 x 11 1/2 inches

I

ILLUMINATIONS, DRAWINGS
AND WATERCOLORS

LATE THIRTEENTH CENTURY ITALIAN MASTER
Perhaps Bologna

1. *St. Helen with the True Cross*, about 1290

 A very large initial "N" cut from a manuscript choirbook on vellum
 173 x 137 mm.; 6 7/8 x 5 3/8 inches

 Verso:
 With the part of 3 lines each of text in a rounded gothic hand and of music on a 4-line red stave, cut to shape.

 Notes:
 1. The unusual prominence given to the cross in this work could suggest a church dedicated either to Santa Croce or St. Helen. This miniature probably illustrated the introit "Nos autem gloriari" sung at the Mass both on the feast of *The Finding of the Cross* (May 3) and on the feast of *The Exaltation of the Cross* (September 14).
 2. In this work, a standing figure of an elderly St. Helen in bright orange-red holds a Cross above and gives it over to a younger sainted man in a pale grey-blue robe on the left. This scene probably refers to St. Helen and her son Constantine. This miniature is painted in colors seen against a deep-blue ground with delicate white tracery within a very large initial in soft colors, in a leafy design on a panel ground.

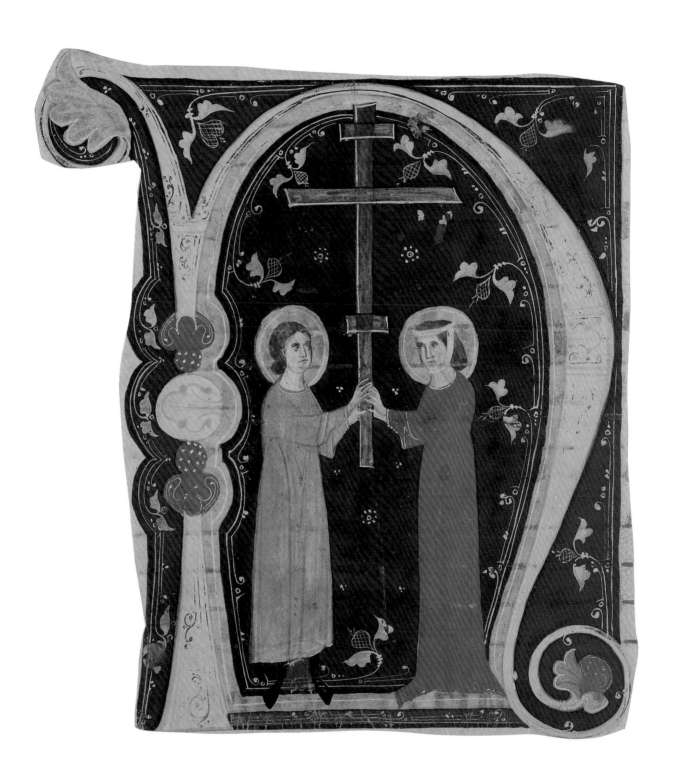

MARTINO DI BARTOLOMEO (attributed to), active around 1382-1402
Tuscany, (probably Lucca)

2. *St. John the Baptist Preaching*, about 1395-1402

A large historiated initial cut from an illuminated manuscript antiphon on vellum
204 x 173 mm.; 8 x 6 15/16 inches

Verso:
Part of 3 lines of text and 2 of music, cut roughly to shape with edges of illuminated
extensions partly cropped.

Provenance:
1. From a set of choirbooks probably made in Lucca for the Carthusian abbey of
 Santo Spirito (founded in Lucca in 1338), apparently as a gift from Nicolo di
 Lazzaro Guingi (d. 1435), archbishop of Lucca 1394-1402, whose arms appear in
 several cuttings from the same series.
2. James Dennistoun (1803-1855), the Scottish antiquary who first identified Piero
 della Francesca, bought this with other initials in Lucca in 1838. Dennistoun
 wrote: "on the invasion of Italy by the revolutionary armies of France, these
 beautiful books were plundered, and fell into the hands of some boors, who
 proceeded to cut up the broad parchment leaves, wherewith to cover their flasks
 of olive oil. Fortunately someone rather less barbarous rescued these initials by
 crudely cutting them out. The collection thus saved was bought by me at Lucca".
3. Dennistoun's grandaughter, Mrs. Herbert Hensley-Henson, Auckland Castle,
 wife of the bishop of Durham 1920-39 ("we call them Uncle Denny's scraps", she
 said, as cited by J. Pope-Hennessy, *Learning to Look*, 1991, p. 29).
4. Kenneth Clark, Lord Clark of Saltwood, O.M. (1903-1983), bought c. 1930.
5. Kenneth Clark, Lord Clark of Saltwood, O.M. (1903-1983) sale, Sothebys, July 3,
 1984: lot 93(4) .

Notes:
1. In this work, with its fine, bright, fresh colors, there is shown a three-quarter-
 length bearded figure of St. John the Baptist, facing forwards with one hand raised
 and with his finger pointing to Heaven and the other lightly holding a tall narrow
 Greek cross. St. John is dressed in grey skins, mostly covered with a pink cloak
 lined in olive-green, against a deep blue lapis ground within a flamboyant colored
 leafy initial "A". It has been suggested that this is perhaps an "Audite insulae"
 from Lauds on the feast of *The Nativity of St. John the Baptist* on June 24. This work
 is presented on a highly burnished gold ground with leafy extensions in colors and
 burnished gold and is on a cutting with part of lines of text above and to the left
 with ends of 4-line red musical staves.
2. This is a localisable and datable Italian gothic miniature of excellent quality and

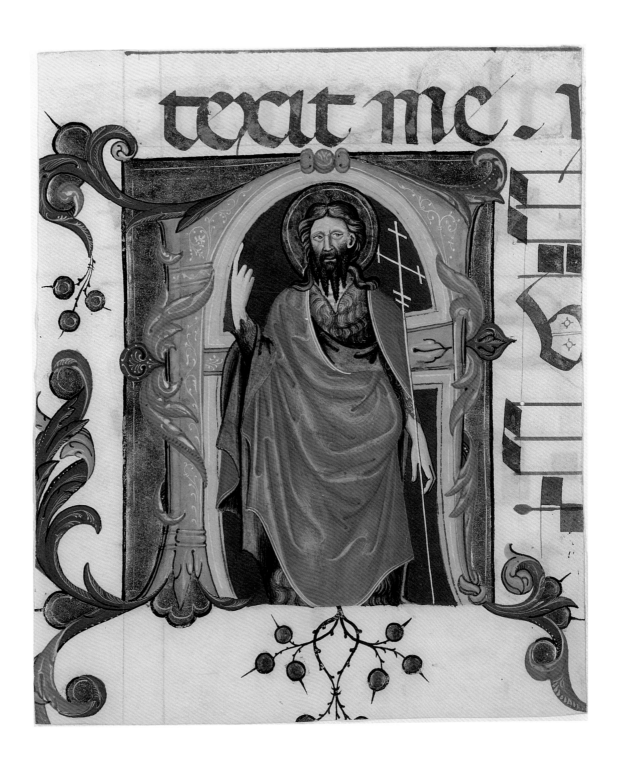

important provenance. Three further cuttings from the same manuscript are in the Breslauer Collection where they also are attributed to the Sienese fresco painter and illuminator Martino di Bartolomeo (died 1434) who was active in Lucca from 1382 to about 1402 and who painted a 5-volume Gradual still in Lucca cathedral (Voelkle and Wieck, *Breslauer Collection*, 1992, pp. 181-5, with further references, and F. Todini, *Una Collezione di Miniature Italiane*, 1993, citing the present miniature on pp. 41 and 43). The swirling drapery and the long fingers here, as well as the form of the initial itself, can be compared closely with the miniature of *St. Helen* by Martino di Bartolomeo in the Lucca Gradual (M. Ciatti in *Il Golico a Siena*, 1982, fig. on p. 309). Some other miniatures from the Dennistoun series of cuttings were perhaps unfinished, and work on the manuscript may have been abandoned in 1402 when Archbishop Lazzaro Guinigi was expelled from his diocese.

SOUTHERN NETHERLANDS MASTER (Bruges)

3. *The Virgin and Child with Kneeling Donor*, circa 1430-40

A full-page miniature from an illuminated manuscript Book of Hours on vellum
97 x 78 mm.; 3 15/16 x 3 1/16 inches

Notes:
1. This miniature is from the Bruges group of manuscripts ascribed to the Master of the Gold Scrolls. In this work, through a window into a manuscript miniature, there is shown a meeting of a contemporary medieval woman with the Mother of God. This juxtaposition of secular and divine was a particularly fascinating theme for northern European painters of the fifteenth century. The woman here represents the original owner of the Book of Hours. She is shown in her finest robes, being led by an angel over the frame of the miniature to the edge of Heaven itself. The Christ Child looks backwards and sees the woman across the divide. See: G. Dogaer *Flemish Miniature Painting in the 15th and 16th Centuries*, 1987, p. 29, pl. 8, where, in a very similar miniature from the same workshop, the woman, trailing her dress into the border, has actually crossed into the miniature.
2. In this work, the Virgin and Child are seated on a cushion in a grassy meadow in a blaze of radiating lightbeams terminating in stars against a scarlet ground and with an arc of blue sky above. The miniature is in a gently arched compartment with a broad three-sided burnished gold illuminated baguette border. There is a full border of colored flowers and acanthus sprays infilled with tiny burnished gold ivy-leaves. There is a fine portrait of a kneeling woman wearing a *hennin* and a pink cloak trimmed with ermine over green sleeves and attended by two half-length angels from above and in the lower margin.

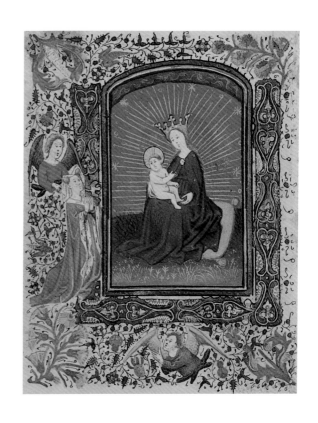

NORMANDY MASTER (probably Rouen)

4. *The Annunciation*, about 1430

Large miniature on a leaf from the *Tarleton Hours*, in Latin.
An illuminated manuscript on vellum
138 x 100 mm.; 5 1/2 x 4 inches

Provenance:
From the *Tarleton Hours*

Notes:
1. This illuminated manuscript was f.14 in the *Tarleton Hours*. Rather unusually, it illustrated the Gospel Sequence from *St. Luke*. The result was that when the artist came to paint a miniature for *Matins* on f.20, the traditional subject of the *Annunciation* had already been used and he painted instead the owner kneeling before the *Coronation of the Virgin* (Maggs, Bulletin 6, 1969, no.7, with plate). It has been noted that the kneeling figure of Gabriel, here depicted looking upwards in profile with his wings half raised and clasping a fluttering scroll, is very characteristic of the Rohan style and, in fact, is found in the *Rohan Hours* itself and in several other manuscripts from the Master's workshop (M. Meiss, *The Limbougs and their Contemporaries*, 1974, figs. 835, 868 and 883).
2. In this work, the Virgin Mary is reading a manuscript on a desk before a chair beneath an embroidered red canopy. Gabriel is shown kneeling on the right and looking up with a banderole "ave gra[tia] plena". God appears in the sky above, surrounded by cherubim and seraphim and sending down the Holy Dove to whisper into the Virgin's ear. There is a green tiled floor with a golden vase of lilies, a purple cloth behind, embroidered in gold, diaper background, all painted in full colors and liquid and burnished gold in an arched compartment, all above a heading and large illuminated initial "I" ("In illo tempore...") and 6 lines of text in a *lettre bâtarde*.. Finally, there is an illuminated baguette border plus border with clumps of colored acanthus leaves in the upper corners and sprays of small colored and burnished gold leaves on hairline stems.

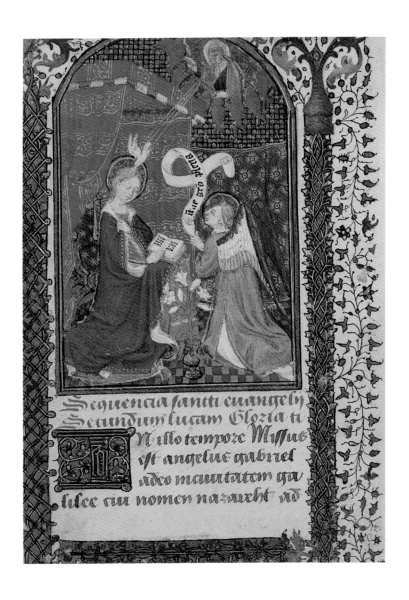

SOUTHERN NETHERLANDS MASTER (possibly Tournai)

5. *The Flight into Egypt*, about 1465

Large Miniature on a leaf of an Illuminated Manuscript Book of Hours on vellum
182 x 124 mm.; 7 1/8 x 4 7/8 inches

Provenance:
The 3rd Marquess of Bute (1847-1900)
The Marqueses of Bute

Notes:
In this beautifully depicted scene, the Virgin and Child on a tired donkey are
guided off to the right by Joseph who is shown holding a stick and a bundle over
his shoulder. All this activity is placed in a pebble-strewn meadow with fields
behind and a distant view of tall cities on the horizon. This scene is here described
in full colors with liquid gold haloes in a gently arched compartment. This
compartment is placed above a large initial and four lines of text (opening of
Vespers, heading in red, in French). There is a full border of colored flowers and
acanthus leaves infilled with burnished gold ivy-leaves on hairline sprays. On the
verso, there are 17 lines of text in a gothic liturgical hand (including Vespers
antiphon "Beatam me dicunt"), illuminated initials and line-fillers.

NORTHERN FRENCH MASTER

6. *The Virgin and Child Enthroned*, Northern France, perhaps Paris, about 1500

Large Miniature on a leaf of an illuminated manuscript in French verse on vellum
214 x 150 mm.; 8 1/2 x 5 7/8 inches

Notes:
This work is from a *Book of Hours* or similar prayerbook. Here the Virgin is shown
crowned and holding the Child as two angels hover at the sides lifting the curtains
of a canopy around the throne. The miniature is painted in colors and liquid gold.
This scene is presented above a large initial and the verse in French (which is
complete): "Glorieuse virge marie" (see: A. Langfors *Les Incipit des poèmes français*,
1917, p. 149). The verso is ruled for twenty-seven lines, with full-length panel
border of colored flowers and acanthus leaves on partially-colored gold ground.

(not illustrated)

14

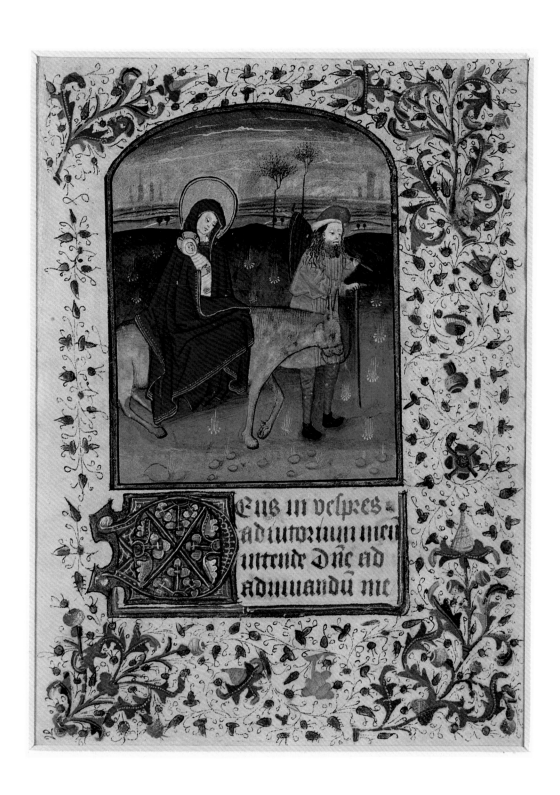

VENICE MASTER (middle 16th century)

7. *St. Vincent Ferrer Kneeling Before the Virgin and Child* , Venice, about 1540

Miniature on the frontispiece of a Ducale on vellum
225 x 155 mm.; 8 7/8 x 6 1/8 inches

Provenance:
1. This is the frontispiece of a *Ducale* issued by Pietro Lando (who was Doge of Venice 1537-1543) to a member of the Ghisi family (Vincente Ghisi=V.G. as seen below).
2. William Young Ottley (1771-1836). Included in the sale of the Ottley Collection in 1838 (Sotheby's, May 12, 1838: lot 228 where catalogued as "by Beneditto Bordonne, about 1538") and where sold for ƒ 1.11s to "Rodd for Holford".
3. Robert Stayner Holford (1808-1892): catalogue, no. 75, plate LXIX. A.N.L. Munby: *Connoisseurs and Medieval Miniatures*, 1972, p. 147 described Holford:

 ...If one wished to depict an Ideal Connoisseur the result might well resemble Robert Holford. With his long hair, imperial beard, wide brimmed hat, and much be-frogged cloak he looked more like a spruce Dante Rossetti than a millionaire who changed the appearance of central London by erecting Park Lane and his vast Italianite palace, Dorchester House.

4. Sir George Holford (1860-1926). By descent from Robert Stayner Holford.
5. Edwards Collection, from the George Holford Sale July 12, 1927: lot 47.

Notes:
1. This work, catalogued for over a century as depicting St. Anthony of Padua, we now are correctly cataloguing as depicting Saint Vincent Ferrer (c. 1350-1419), a Spanish Dominican friar, reputed to have been the greatest preacher of his age. In 1394, Vincent had been summoned by the Avignon pope Benedict XIII as the pope's personal confessor and theologian. Five years later, Vincent resigned and set out on a missionary enterprise that took him on preaching tours through Burgundy, Switzerland, northern Italy (Venice) and Spain. In 1412, Vincent was one of nine judges who elected Ferdinand I to the throne of Aragon. It was Vincent who prevailed on Ferdinand I to abandon the cause of Benedict XIII in order to help end the western papal schism. In this work, Vincent is depicted in a white robe (which would have been brown for a Franciscan such as St. Anthony of Padua) with a brown shawl. The flames in the saint's right hand (which in the case of this saint sometimes are shown on top of his head) are the most typical identifying mark of Saint Vincent Ferrer. The strong sun in the background, the image of the wisdom of the church, is still another symbol attached particularly to this preacher-saint (see: Otto Wimmer *Kennzeichen und Attribute der Heiligen,*

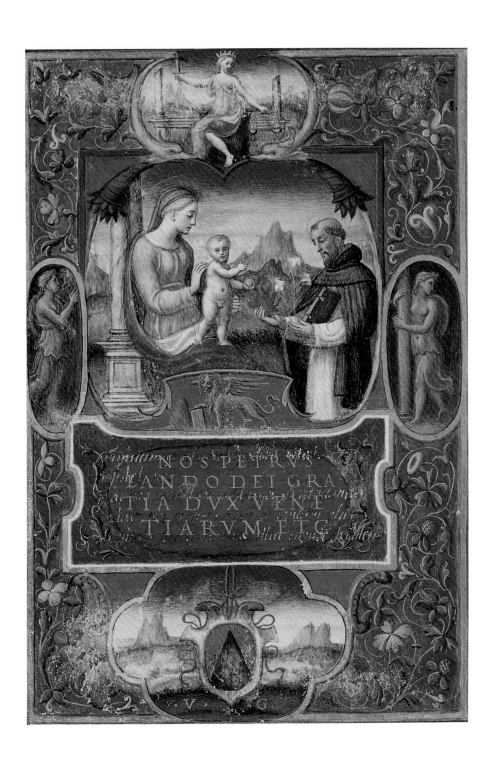

Tyrolia Verlag, Innsbruck, 1975: pages 32, 103 and 182).

2. In this work, the Virgin is shown with the Child pointing towards Saint Vincent Ferrer who holds flames, a triple lily and a book, all set within a landscape background. There is the Venetian lion of St. Mark below. There is a full border of gold and colored flowers on a pale blue ground with vignettes of Justice and two classical maidens (in *camaieu d'or*). The arms of Ghisi of Venice are suspended in a landscape and flanked by the initials "V.G." (Vincente Ghisi) together with the opening of the text in a central panel in gold capitals (with some offsetting of the script below the miniature) on a red ground.

GIOVANNI BATTISTA FRANCO called **IL SEMOLEI**
Venice 1498-1561 Venice
after **MICHELANGELO BUONARROTI** (Caprese 1475-1564 Rome)

8. *The Archers*, about 1540

Pen and brown ink with wash; laid down
223 x 290 mm.; 8 7/8 x 11 1/2 inches
Inscribed on the verso: EE 27/10

Provenance:
Jonathan Richardson Senior (Lugt 2183)
Benjamin West (Lugt 419)
A private Continental collector

Notes:
1. This fascinating, sensitively worked drawing, executed about 1540 by Giovanni Battista Franco, is after Michelangelo's famous drawing, *Archers Shooting at a Herm* now in the British Royal Collection and presently at the Royal Library in Windsor Castle. The subject of the drawing, showing male and female archers (without bows and arrows, however), would appear to relate to a now lost decoration in the *Volta Dorada* in Nero's house in Rome. The archers are aiming at a half-figure or "Herm". (In ancient Greece a "Herma" was a square pillar of stone, topped with a bust or head of Hermes used as a milestone or signpost.) To this day there still is question as to the meaning of this subject. Franco, in his drawing, has left out the "Herm" to the far right. On the other hand, Franco has included a left-hand area (the feet of archers) and an upper area (the extended arms of the archers) which must have been present in Michelangelo's original drawing but which no longer are left in the drawing as it now is to be seen in Windsor. In this respect, as a document, Franco's drawing would appear to be most informative as to the original appearance of Michelangelo's drawing.
2. Concerning Michelangelo's drawing at Windsor, it is to be noted that on its verso

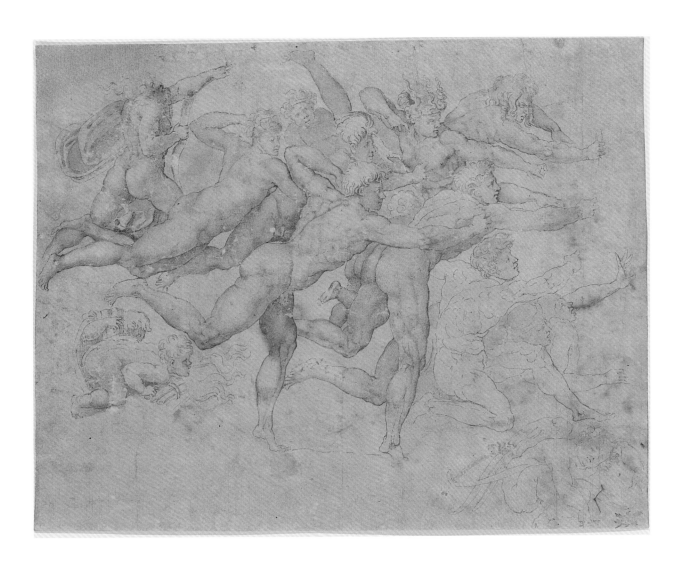

there are two inscriptions (in two hands): "D. Giulio Clouio copia di/Michiel Angeli" (Don Giulio Clovio copy of Michelangelo) and "andrea quaratesi venne . quj adi/12 . di ap[r]ile . 1530 . edebbe [a io] p man[d]are . asno . padre . apisa" (Andrea Quaratesi came here on 12 April and had ten ducats to send to our father in Pisa). The second of these two inscriptions (see: Jane Roberts *Italian Master Drawings: Leonardo to Canaletto: From the British Royal Collection*, London, 1987: no. 20, page 60) apparently refers to a transfer of ten ducats from Michelangelo and/ or his brothers to their elderly father then living in Pisa during the period of the siege of Florence by the Imperial Troops in 1529/30. The first of these inscriptions would appear to attribute the Windsor drawing to Michelangelo's younger contemporary Guilio Clovio (Grisone known as Grizane in Croatia c. 1500-1578). However, it now appears generally agreed that the Windsor *Archers* is by Michelangelo and probably once belonged to Clovio who collected and was particularly influenced by Michelangelo's drawings. One reason that art historians seem so unified on this question has been shown by Alexander Perrig (*Michelangelo's Drawings: The Science of Attribution*, Yale University Press, 1991: p. 42): "...to admit the copy status of the [Windsor] drawing would have meant admitting that the *Resurrection* in Windsor..., which is signed by the same writer ('D. Giulio Clouio'), was an independent creation of Clovio's". Such an admission would have created an academic "avalanche"!

3. Giovanni Battista Franco, though Venetian by birth, spent most of his early years in Central Italy and arrived in Rome in 1530, thirty-four years before the death of Michelangelo and probably some ten years before executing this drawing after Michelangelo. As already pointed out by Vasari, Franco lived in Rome "for no other reason than to study and imitate the drawings, paintings, and sculptures of Michelangelo" (Giorgio Vasari *La vita di Michelangelo nelle redazione del 1550 e del 1568* Ed. P. Barocchi, 4 vols. Milan and Naples, 1962: vol. I, p.265). Already in his earlier works produced mostly in Urbino, Franco had shown the deep influence of Michelangelo. Some slightly later paintings such as the *Allegory of the Battle of Montemurlo*, c. 1537 in the Pitti Palace in Florence and the c. 1541 fresco of the *Arrest of Saint John the Baptist* in the Oratory of San Giovanni Decollato in Rome also were clearly inspired by the works of Michelangelo. Michelangelo's influence also is felt in many of Franco's more personal drawings such as, for example, the *Sheet of Studies with Several Figures* in the Louvre (see: *Roman Drawings of the Sixteenth Century from the Musée du Louvre*, Art Institute, Chicago, 1980: no.: 24, p. 65). In any case, different from other contemporary copies of Michelangelo drawings, this present drawing shows the typical crosshatching and fine parallel, etching-like strokes that we associate with Giovanni Battista Franco. In addition, the musculature, which is even more taut than that of Michelangelo's original, is a typical element of Franco's particular graphism.

4. There are a few other early copies of Michelangelo's *Archers*.. One of these is a drawing by Bernardino Cesari (died 1614) (ref: A.E. Pophan and J. Wilde *The Italian Drawings of the XV and XVI Centuries in the Collection of His Majesty The King at*

Windsor Castle, London, 1949: no. 456). Cesari's later drawing also indicates what must have been the left-side and upper extensions of Michelangelo's original drawing. Another is an engraving by Nicholas Beatrizet (1515-1565) (ref: Passavant VI, p. 120, no. 116). Beatrizet's engraved copy of Michelangelo's drawing has added bows and arrows in the hands of the archers. Various copies of other Michelangelo drawings were executed a bit later by Giovanni Battista Naldini (Fiesole c. 1537-1591 Florence). None of the above artists would appear to have been inspired by quite the same passionate admiration of Michelangelo evidenced in the more immediate drawings of Giovanni Battista Franco.

5. The provenance of this work is of great interest. Jonathan Richardson Senior (1665-1745) was a portrait painter and one of the most distinguished collectors of the entire eighteenth century. Richardson and his son, according to Lugt, were among the greatest art connoisseurs of their times and particularly of works from the Italian School. In 1722, they published *An Account of Some of the Statues, Bas-reliefs, Drawings and Pictures in Italy* (2 vols.). In 1715, Richardson Senior had published his *Essay on the Theory of Painting* and, in 1719, he published his *Essay on the whole Art of Criticism in Relation to Painting* and his *An Argument in behalf of the Science of a Connoisseur*. Besides amassing a superb collection for himself, Richardson Senior also "arranged" a goodly part of the extraordinary collections of the Duke of Devonshire and of the Earl of Pembroke. Lugt describes Richardson Senior as having a "sure eye" which allowed him to triumph over his competitors even though these latter often were richer than he. The second notable collector who once owned this drawing was Benjamin West (1738-1820). Benjamin West was born in Springfield, Pennsylvania and worked in Philadelphia and New York before studying in Italy from 1760 to 1763 and then exhibiting in London from 1764 onwards. In 1772, George III named West the Royal Painter of History. Twenty years later he followed Sir Joshua Reynolds as President of the Royal Academy. West actively collected Old Master prints and drawings. These included an extensive collection of drawings by Fra Bartolomeo contained in two volumes. They had been left to a nun, Plautilla Nelli, Fra Bartolomeo's student. The now famous drawings were forgotten in a convent, then were acquired by the Grand-Duke of Tuscany after which, under strange circumstances, they arrived in England in the hands of Banjamin West in 1805. This appears typical of West's collecting agressivity. In any case, Michelangelo exerted a great influence on West. This influence can be seen, for example and perhaps via this very drawing, in the group of warriors in Benjamin West's own painting *The Destruction of the Beast and the False Prophet* in the Minneapolis Institute of Arts.

PAOLO FARINATI
Verona 1524-1606 Verona

9. *The Triumph of a Roman Emperor*

Pen and brown ink and black chalk
445 x 330 mm.; 17 1/2 x 13 inches
Inscribed on the verso: EE 27/10

Notes:
1. Farinati, a student of Niccolo Giolfino and A. Badile, also had studied the works of Parmigianino, Tiziano, Giorgione and particularly Giulio Romano. In this magnificent drawing, there are numerous exact parallels seen in many of Farinati's etchings. This artist's very special treatment of hands is seen in virtually everyone of his prints reproduced in *The Illustrated Bartsch* (Vol. 32, New York, 1979: pp. 259-269). The treatment of the "cupids" in the upper-left of this drawing is paralleled by the putti in Farinati's *The Drunken Satyr* (*Illus. Bartsch* p. 267).

2. Farinati's son, Horazio Farinati (1559-c. 1616), was a student of his father. A number of his paintings, including the *Descent from the Cross*, now in the church of St. Paul in Verona, were virtually exact copies of his father's works. In addition, Horazio's engravings were all executed directly after his father's drawings. In this respect, this drawing by Paolo Farinati appears to be a clear inspiration for Horazio's *Scene of Battle* engraving (*Illus. Bartsch*, no. 6, p. 274), in which there is an identical and very personal presentation of several of the figures and horses.

Horazio Farinati after Paolo Farinati *Scene of Battle* engraving

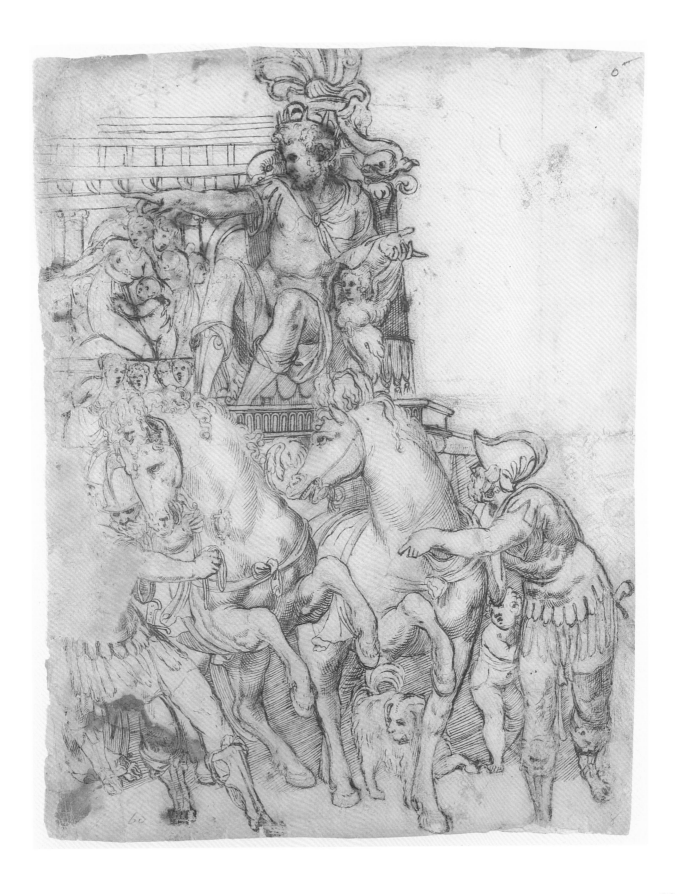

RAFFAELLO MOTTA called RAFFAELLINO DA REGGIO
Reggio Emilia 1550-1578 Rome

10. *Madonna and Child Appearing to Saints John the Baptist and Francis,* *about 1575*

Pen and brown ink with wash over red chalk; squared in black chalk for transfer
410 x 279 mm.; 16 1/8 x 11 inches
Inscribed in pen and brown ink: Raphael da Regio

Notes:

1. Raffaellino arrived in Rome in 1572 and, in his short life, had only a few years in
 which to establish himself. Catherine Monbeig Goguel (*Roman Drawings of the
 Sixteenth Century from the Musée du Louvre*, The Art Institute of Chicago, 1980: page
 110) cites, among other projects of Raffaellino, the artist's part in the circa 1575
 decoration of the Farnesi Palace at Caprarola where he had been introduced by
 Giovanni de Vecchi (1537-1615) who seems to have "taken offense" at the artist's
 "talent". Monbeig Goguel describes Raffaellino as "one of the most original artists

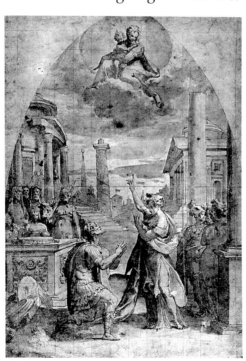

in a period when the majority of painters,
primarily decorators, remained prisoners
of the *maniera* of Federico Zucarro".
Monbeig Goguel is perhaps correct in
calling Raffaellino, rather than Federico
Zuccaro, the "true artistic heir" of Taddeo
Zuccaro even though Raffaellino could
not have personally known Taddeo
Zuccaro who died in 1566. It is interesting
to note that Raffaellino actually replaced
Federico Zucarro in the decoration of the
Palazzina Gambara at Bagnaia (see: M
Brugnoli *Villa Lante a Bagnaia*, Milan, 1961,
p. 114). Monbeig Goguel makes a clear
separation of the *maniera* of Raffaellino
from that of Federico Zuccaro. However,
there would appear to be an apparent
closeness between the two artists to be
seen, for example, in comparing this draw-
ing with the drawing now assigned to Federico Zuccaro (illustrated to left) *The
Tiburtine Sybil Foretelling the Birth of Christ to the Emperor Augustus* (*Old Master
Drawings from Chatsworth*, International Exhibitions Foundation, 1987: no: 78, page
129). The composition of this latter drawing, with its open, sweeping and broad
conception as well as in its details, such as the special "curly-cues" on the hair of
the Christ child and of the "Sybil", are very close to this present sheet. Now also
assigned to Federico and also close in a number of respects is Federico's *Design for*

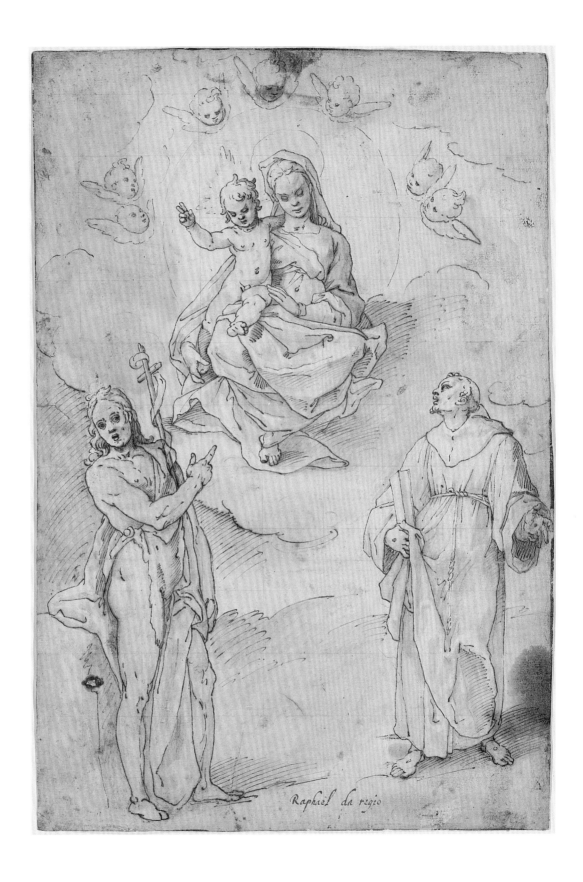

Raphael da regio

a Quarant 'Ore Decoration at the Metropolitan Museum of Art (see: *Sixteenth Century Italian Drawings* Metropolitan Museum of Art, New York, 1994: No. 86, p. 230).

2. Two other Raffaellino drawings, which could be compared to the present sheet, were in the collection of the British Rail Pension Fund and were auctioned by Sotheby's in New York on January 11, 1990. These were *God the Father with Angels in a Lunette* cat. no. 44 and *The Holy Ghost Surrounded by Angels Holding Musical Instruments* cat. 45. Both of these drawings present a series of characteristics and personal Raffaellino quirks to be seen also in the present drawing, (special treatment of the feet, the "curlicues", the treatment of the "flying angels", the nature of the pointing fingers, the general composition).

3. In comparing this present elegant drawing to the Louvre's *Martyrdom of Saint Dorothy* by Raffaellino (see reference above: *Roman Drawings,* cat. no. 46), one sees some of the same characteristics noted by Monbeig Goguel as typical of the personal style of Raffaellino: "...its diagonal composition, made rythmic by striking foreshortening, in the heroic tone given to the image figured, in the significant value accorded not only to gesture but to the entire attitude of the body, and also in the beauty of the lighting". There also is, in common with the Louvre drawing, the special Raffaellino "pointing hand" and the "curly-cues" in the hair of Saint Dorothy and the Angel also found in the present drawing's treatment of the hair of both the Christ child and St. John the Baptist.

4. In placing Raffaellino together with the more well known Federico Zuccaro as perhaps the two principle heirs of Taddeo Zuccaro, a reconsideration of the drawings of both of these "heirs" would certainly assign some drawings, until recently attributed to either Taddeo or Federico, as being within the oeuvre of Raffaellino. Drawings to be so reconsidered could include the above-illustrated Chatsworth drawing as well as the Metropolitan Museum drawing cited above, both now assigned to Federico Zuccaro. For comparative purposes, there are a number of the drawings of Raffaellino in the Uffizi (see: J. Gere exhibit cat. *Disengni degli Zuccari*, Florence, 1966: nos. 79 to 88, figs. 53 to 58). In the 1966 Florence exhibition, it is notable that Gere catalogued a total of ten Raffaellino drawings, two of which had been previously attributed to Taddeo Zuccaro and one to Federico Zuccaro.

ADRIAEN VAN DE VELDE
Amsterdam 1636-1672 Amsterdam

11. ***Horses and Cattle in a Wooded Landscape***, about 1663

Pen, brown ink and grey wash
150 x 200 mm.; 5 15/16 x 7 15/16 inches

Verso: mark of J. de Vos

(description follows on next text page)

26

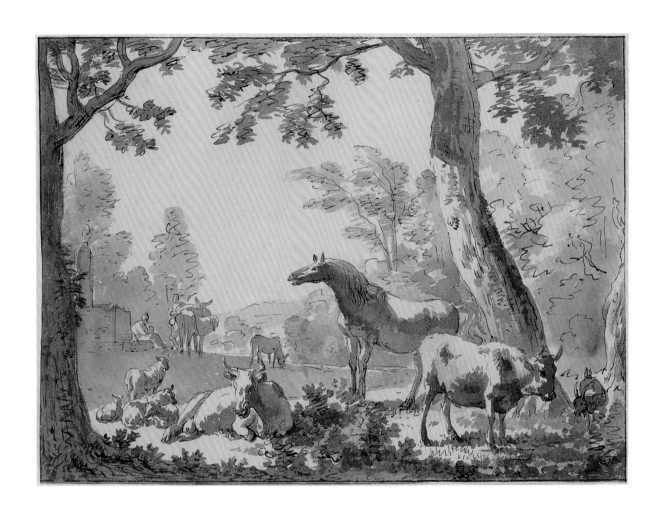

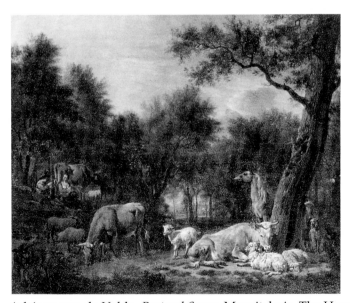

Adriaen van de Velde, *Pastoral Scene*, Mauritshuis, The Hague

Provenance:
J. Goll van Franchenstein no. 15
Vente Mensing, April 27-29, 1937: no. 741, where acquired by M. Hirschmann for 48 Dutch Fl.
A private Belgium collector

Notes:
This is one of two known drawing-studies for a painting of 1663 (illustrated here on page 27) of the same subject in the Mauritshuis in The Hague (no. 197 and Hofstede de Groot no. 140). The other was in the collection of Emile Wolf in New York (see: Herbert F. Johnson Museum of Art, Ithaca, New York *Dutch Drawings of the Seventeenth Century from a Collection*, 1979, no 50, illustrated and see: W.R. Robinson *Master Drawings*, 1979, XVII, p. 19, no. B3). Robinson (ref. above) notes that practically all of Van de Velde's known preparatory drawings for paintings, which would include this one, fall in the last decade of the artist's brief career. With respect to Van de Velde's working methods, it appeared that he went into the fields at least once a week in order to sketch horses and cattle in landscapes. On this, see: Arnold Houbraken *De Groote Schouburgh der Nederlantsche Konstchilders en Schilderessen...*, III, Amsterdam, 1721, p. 90 (also cited by Robinson, note 12, ref. above).

CARLO MARATTA
Camerano 1625-1713 Rome

12. ***Madonna and Child and Saint with Two Angels***, about 1680

Red chalk on a green-blue paper, with rounded top
422 x 275 mm.; 16 5/8 x 10 7/8 inches

Provenance:
Collector's mark, lower center (not in Lugt)

Notes:
1. This confidently executed drawing is a study related to Maratta's painting *La Vergine appare a S.Stanislao Kotska* 1687 in the second chapel to the right, in the church of S. Andrea al Quirinale in Rome (see: Amalia Mezzetti *Contributi a Carlo Maratti*, no. 93 on page 333 in : *Rivista dell'Istituto Nazionale d'Archeologia e Storia dell'Arte*, vol. 4, 1955). Mezzetti (ref. above, pp. 352-53 *Appendice-Documenti inediti*) records the original contract of September 22, 1679 in which Maratta agreed to terminate this painting for the "Cappella del Beato Stanislao" in one year for

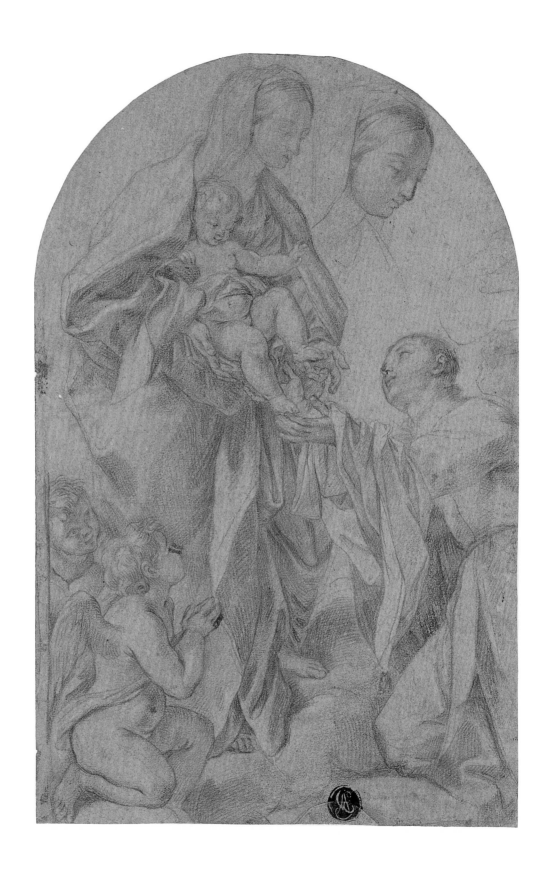

"scudi 100 o altra somma che havessi presa". In spite of this contract, Maratta did not finish this painting until 1687. Mezzetti (ref. above) records Maratta's note stating that, on September 19, 1687, Maratta received "Scudi Trecento" from the "mano del P. Giuseppe Tonini della Compagnia di Giusù"(sic) and that Father Tonini was "interamente sodisfatto" (see: *Fondo Gesuitico al Gesù di Roma*-S. Andrea al Quirinale Filza 865, fascicolo 13).

2. Two other drawings related to this commision are in the Düsseldorf Kunstmuseum: Ann Sutherland Harris and Eckhard Schaar *Die Handzeichnungen von Andrea Sacchi und Carlo Maratta*, Düsseldorf, 1967, vol. I, nos. 348 and 349. This particular drawing could be compared to a number of the Maratta drawings, formerly from Lambert Krahe's (1712-1790) extensive collection, most of which now are in the Düsseldorf Kunstmuseum. One of these (*Facetten des Barock: Meisterzeichnungen von Gianlorenzo Bernini bis Anton Raphael Mengs aus dem Kunstmuseum Düsseldorf/ Akademiesammlung*, Düsseldorf, 1990 cat. no. 35 "Study of a Tree Nymph", about 1680) shows a very similar use of red chalk on a green-blue paper with a rounded top as well as a similar treatment of a woman's head. Another of these (ref. above, cat. no. 36 "Head of a Woman with Two Studies of Hands", about 1695) shows a virtually identical and highly personal treatment of the hand as seen in the left hand of the Madonna in the present drawing. This drawing, however, does find certain parallels in some of the earlier drawings of Giancinto Calandrucci (1646-1707) who entered Maratta's studio around 1680. For example, the figure in "Study for the Figure and the Hands of Saint Pasquale Bayon" in the Louvre (probably also with a Lambert Krahe provenance and no. 62-G and reproduced on page 74 of: *La Rome baroque de Maratta à Piranèse*, The Louvre, 1990). However, in this latter drawing the "hands" are very different than those in the present drawing or those in the second of the above-mentioned Düsseldorf Maratta drawings. On the other hand, the compositional posture of the Madonna and Child with respect to the kneeling saint is repeated in Maratta's "Vierge et Enfant avec Saint Charles Borromée et Saint Ignace de Loyola "(see Louvre reference above: cat. no. 20-A and reproduced in color on page 14). Other differences could be noted between the drawings of Maratta and those of Calandrucci and also those of another follower, Guiseppi Passeri (1654-1714). In this respect, Harris and Schaar (see: ref. above, pp. 80-81, plates 67 and 8) illustrate similar subjects drawn by Maratta, Calandrucci and Passeri. In comparing Maratta's drawing in this case (plate 6 and also *Windsor, Roman Drawings*, no. 340) with Calandrucci's drawing (plate 7 and also Düsseldorf Inv. F.P. 12677), the treatment of the Maratta clearly corresponds more closely to our drawing. This again is reaffirmed by the reproduction of the more worked-over Passeri drawing (plate 8 and also Dusseldorf Inv. F.P. 2419). Again referring to Harris and Schaar (see ref. above), the treatment of the drapery-folds on No. 10 Maratta (cat. no. 233a on page 101) is most similar to our present drawing and the same could be said for cat. no. 320 on page 122.

3. A major way in which Maratta is to be distinguished from the more agitated and also more baroque-like works of his immediate followers , such as Calandrucci

and Passeri, is Maratta's overt and constant reference to Raphael. This is to be seen, for example, in the difference between Calandrucci's more belabored treatment of drapery, to be seen in his drawing at the Louvre, cat. no. 62-A in the Louvre catalogue cited above, as compared to the more Raphaelesque treatment of the drapery in the present drawing. During Maratta's formative period in the studio of Andrea Sacchi (1599-1661), Maratta not only studied Sacchi's sources in the Carracci but he already was even more drawn to Raphael. In those years, Maratta painted numerous small-sized "Raphaelesque" Madonnas. In Maratta's case, it was not only a return to some of Raphael's figure treatments which was in question. It also was a return to a certain "classical" calm seen in Raphael and also in Maratta but not to be found to the same extent in the works of Maratta's immediate followers. This special influence of Raphael is present throughout Maratta's entire career. As still another example, there is the Louvre's drawing "La Divine Sapience" (see ref. above, cat. no. 23 and reproduced in color on page 13) which also shows Maratta's rich but sensitive use of red chalk, a use which we see paralleled in this present drawing. Even at the height of his glory, Maratta returned to the chambers of the Vatican in order to copy Raphael's frescos. It was because of Maratta's importance in Rome at that time, and also because of Maratta's special interest in Raphael, that Pope Innocent XI asked Maratta to be the restorer and the conservator of Raphael's Vatican decorations. A Raphaelesque influenced treatment and "calm" are particularly marking in this present drawing which could be dated to Maratta's maturity in the 1680s.

After PIETRO DA CORTONA (also known as PIETRO BERRETTINI)
Cortona 1596-1669 Rome

13. *Triumph of Divine Providence,* about 1680

Red chalk drawing
279 x 621 mm.; 11 x 24 1/2 inches
Inscribed on verso:
Valiese/n=20-fs 30' (P da Cortona Palazzo Barberini, Rome)

Notes:
1. This splendid drawing of about 1680 is after a section of Pietro da Cortona's vault fresco of *The Triumph of Providence* in the Salone of the Palazzo Barberini in Rome (see: G. Briganti *Pietro da Cortona*, Florence, 1982; plate 127: "Particolare della volta del Salone di Palazzo Barberini"). In this allegorical scene, paralleled by this drawing, Briganti (see reference above, p. 202) sees the figures on the right as Silenus (the "drunken Silenus") with nymphs and *baccante*. On the left, Venus, startled from her bed by Cupid, is chased by Celestial Love. The kneeling figure of Religion, in the center, attends to the Fire of Sacrifice while Wisdom, flanked by Piety, holds up an open book and a lamp. At the time, these were understood as symbols of the Pope's desire for knowledge. All of these figures with their positive attributes and ideals were depicted as being in the service of the Barberini family.
2. In seventeenth century Rome, Pietro da Cortona was a leading exponent of an exhuberant High Baroque. This was different indeed from the Baroque Classicism being created by da Cortona's great rival Andrea Sacchi (1599-1661). As an example of Sacchi's more "classical" approach, see his similar drawing at the British Museum (1963-11-9-26): *Bacchic Procession, with Midas and Bacchus Supporting Silenus on a Donkey* (see: *The Study of Italian Drawings: The Contribution of Philip Pouncy* by Nicholas Turner, London, 1994: no. 79 and reproduced on p. 73).
3. In its "exuberance", composition and technique, this drawing is quite similar to Pietro da Cortona's drawing (the upper and lower sections being viewed seperately) *Saint Ivo Intervening on Behalf of the Poor, With Christ with Saint Jerome and Three Martyr Saints Above* which had been in the Holkham Hall Collection (see: G. Briganti *Pietro da Cortona o della pittura barocca*, Florence, 1982, p. 290; and A.E. Popham and C. Lloyd *Old Master Drawings at Holkham Hall*, Chicago, 1986, no. 108). This latter drawing was a preparatory study for the altarpiece in Sant Ivo alla Sapienza in Rome. This altarpiece, left unfinished after da Cortona's death in 1669, was terminated after 1674 by da Cortona's pupil Giovanni Ventura Borghesi (c. 1640-1708) (see: G. Briganti, *op. cit.*, 1982, no. 138, fig. 282) who could have been the artist who executed this present drawing.

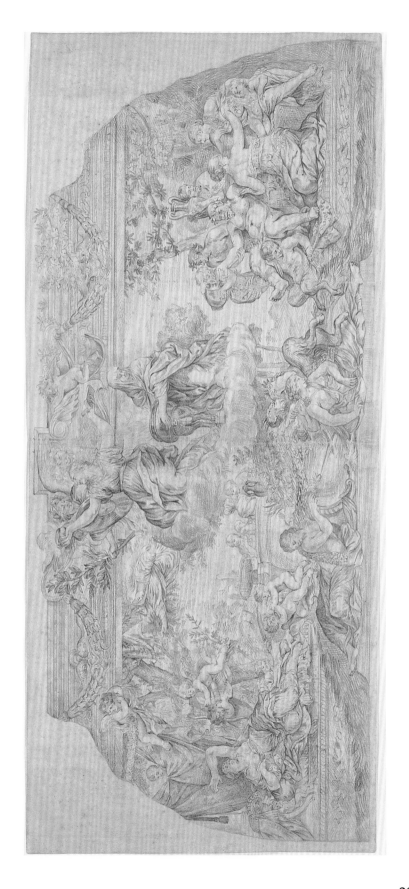

HUBERT ROBERT
Paris 1733-1808 Paris

14. *Rivière près des ruines*, about 1785
(River Near Some Ruins)

Sanguine drawing
352 x 452 mm.; 13 7/8 x 17 7/8 inches

Notes:
1. At the age of twenty-one, Hubert Robert left Paris for Rome. The two major influences he received during his séjour there from 1754 to 1765 were those of Panini and Piranesi. Robert was particularly impressed with Piranesi's drawings and etchings. Piranesi's influence came first from the latter's *Imaginary Prisons* (*I Carceri*) but then from Piranesi's more archeologically orientated *Views of Rome*. The domination of archeological monuments relative to figures in Robert's works derives directly from Piranesi. Different from Piranesi, who, was fascinated with the interior structures of archeological monuments, Robert's interests were less "architectural" and were more directed to the exterior beauty of ruins to be used as backdrops for his idyllic representations of country scenes near Rome and later in France after his return in 1765.
2. Among the French *vedutisti*, Robert was the dominant artistic personality of the second half of the eighteenth century. This was due to his artistic talent and also his sensitivity in understanding the lessons to be learned from both Panini's picturesqueness and the force of Piranesi's architectural point of view. Robert was particularly drawn to Piranesi with whom he apparently traveled and drew together in 1763-1764 (see: *Piranèse et les Français 1740-1790*, Académie de France à Rome, 1976: pp. 22-23 and pp. 304-305). The lessons of Piranesi and Panini remained within the *oeuvre* of Hubert Robert even decades after his return to France and are illustrated by this superb drawing which could be dated to the 1780s.

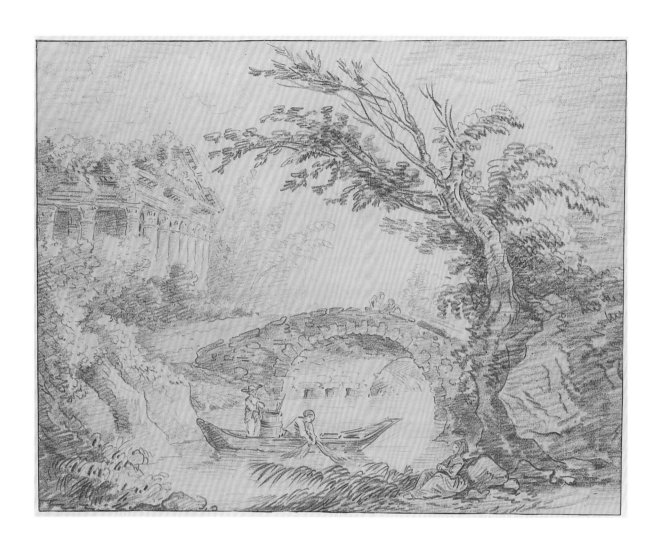

JEAN-LOUIS DESPREZ
Auxerre 1743-1804 Stockholm

15. *Design for a Dome-Shaped Room*

Pen and brown ink with wash, squared in graphite for transfer
275 x 333 mm.; 10 7/8 x 13 1/4 inches

Notes:
1. Desprez was a "painter, engraver, architect, dramatist and designer of gardens and stage sets, and a playwright". (See: Pierre Rosenberg and François Bergot, *French Master Drawings from the Rouen Museum*, National Gallery of Art, Washington, D.C., National Academy of Design, New York, The Minneapolis Institute of Arts and the J. Paul Getty Museum, 1981: p. 28). Above all, however, Desprez was "a prolific and inventive draughtsman, with a turn for the fantastic and visionary". In 1778, the year of the death of Piranesi, Desprez and the landscape painter Claude-Louis Chatelet (who later became an ardent revolutionary and ended up beheaded in 1795 after the fall of Robespierre) arrived in Rome where they executed a great number of drawings used to illustrate the *Voyage pittoresque* by the Abbé de Saint-Non (published in five volumes between 1781 and 1786).
2. This is a very typical drawing by Desprez. A parallel graphism and treatment could be cited, among many other examples, in the upper part of the Desprez drawing in Rouen's *Procession of the Virgin at the Church of S. Filippo in Naples* (see reference above, plate 86, page 158). Compare also to: *Le Palais d'Armide* from the Teatermuseum in Drottningholm (*La Chimère de Monsieur Desprez*, Musée du Louvre, 1994: p. 124, pl. 21) Squared for transfer, this drawing would appear to be a design for a stage set or an architectural project or perhaps simply one of Desprez's "fantasies".

ABRAHAM RADEMAKER
Lisse near Haarlem 1675-1735 Haarlem

16. *Figures in a Landscape*

Pen and brown ink and wash
164 x 157 mm.; 6 5/16 x 6 3/16 inches
Verso: bears inscription Rademaker

Notes:
Rademaker's drawings were among the most beautiful produced in early 18th century Holland. He also engraved a remarkable series of ancient Dutch monuments.

(not illustrated)

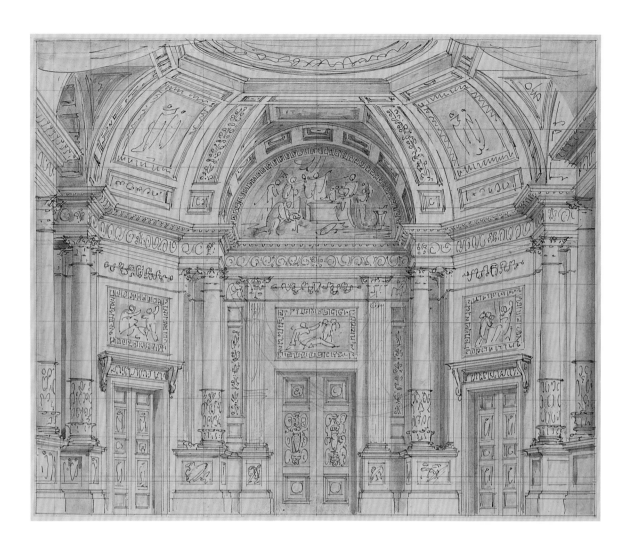

GUILLAUME GUILLON LETHIERE
Guadaoupe 1760-1832 Paris

17. *Venus et Adonis*

Pencil, black chalk, brush with brown and gray ink, blue and brown wash
303 x 360 mm.; 12 x 14 1/2 inches
With inscription; "Guillon Lethière" and on the mount on the back:
"Depart/d'Adonis pour la chasse/dessin fait par Guilon Lethière".

Notes:
1. This is most probably a preparatory drawing for *Un départ d'Adonis* which, with its pair *La mort d'Adonis*, in the 19th century was in the collection of the Duke of Alba in Madrid but whose present whereabouts is unkown. (See: E. Belier de la Chavignerie *Dictionnaire général des artistes de l'école francaise*, Paris, 1882: under "Lethière").
2. Guillaume Guillon, called Lethière, was born in Guadaloupe in 1760. He was the illegitimate son of a French administrator, Pierre Guillon, and a freed slave. In 1774, he left for France to study drawing in Rouen under Jean-Baptiste Descamps and three years later he was in the Paris studio of Gabriel-François Doyen. Lethière was in the Académie de France in Rome from 1786 to 1791 and then in 1807, Lethière was named Director of that same Academie (perhaps, because of Lethière's friendship with Napoleon's brother Lucien). Pierre Guillon finally recognized Guillaume Guillon as his legitimate son in 1799. It was only at this time that the artist took on the name of Lethière which referred to the fact that he then became the third son ("Le thière"="The third") of Pierre Guillon. In 1816, Lethière moved back to Paris where he was a professor at the Ecole des Beaux-Arts and then at the Institut de France in 1822. Lethière was one of a number of French painters who, particularly in the period of 1770-1800, based many of their works on subjects drawn from Greek and Roman history. For further information on Lethière, see: Victor Carlson and Richard Campbell *Visions of Antiquity*, Los Angeles County Museum and the Minneapolis Institute of Arts, 1993: pp. 208-211.

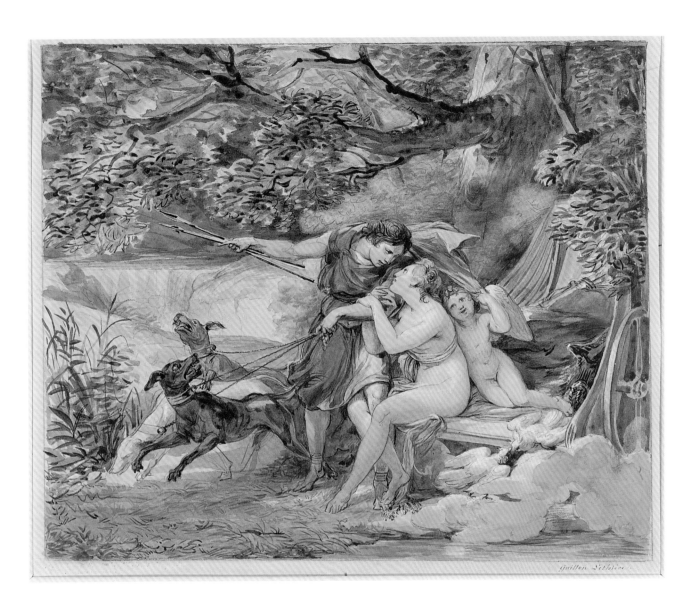

ANTHONIE ANDRIESSEN
Amsterdam 1746-1813 Amsterdam

18. *A Couple Admiring the Ruins of a Castle with Peasants by a Hut in the Background*, 1776

Watercolor over black chalk
245 x 336 mm.; 9 5/8 x 13 3/8 inches
Signed in pen and brown ink, verso: *A. Andriessen desin, ad. viv:/1776*

Notes:
1. Anthonie Andriessen, along with his brother Jurriaan (1742-1819), executed many idyllic views of the ruins of castles and monasteries as they appeared in 18th century Holland. This watercolor of 1776 is an exceptionally beautiful and typical example.
2. Andriessen, born twenty-six years after G.B. Piranesi (1720-1778), considered the ruins of antiquity very differently than his predecessor. Piranesi's interest was that of an artist but also that of an archaeologist and an architect. He was interested as much in the inner construction of the monuments of antiquity as in the their exterior appearance. Andriessen, following the prettified ruin-landscapes created by Hubert Robert (1733-1808) in the immediate suite of Piranesi, made use of the ruins of antiquity simply as romantic and beautiful settings for his depiction of everyday Dutch life.

(not illustrated)

II

ENGRAVINGS, ETCHINGS
AND WOODCUTS

50. Van Ostade, etching

ALBRECHT DURER
Nuremberg 1471-1528 Nuremberg

19. *The Beast with Two Horns Like a Lamb*, circa 1496-97

Woodcut from *The Apocalypse*
392 x 282 mm.; 15 3/8 x 11 inches

References:
1. Bartsch 74
2. Meder 175

Notes:
1. A fine impression from the Latin text edition of 1511.
2. This scene here depicted comes from *Revelation* 13:

> (1) *Then I saw a beast come up from the sea with ten horns and seven heads, and upon his horns ten crowns, and upon his heads the names of blasphemy. (2) The beast I saw was like a leopard, and his feet as those of a bear, and his mouth like the mouth of a lion; and the dragon gave him his power, and his throne, and great authority (3) And one of his heads was as if stricken to death, and the death blow had been healed; and all the world followed the beast in amazement (11) And then I saw another beast coming out of the ground, and he had two horns like a lamb and spoke like a dragon (13) And he prompted great portents, even that fire pour down from the sky to the earth for all men to see .*

And from *Revelation* 14:

> (14) *And I looked, and beheld a white cloud, and sitting upon the cloud one who was like the Son of Man, wearing upon his head a crown of gold, and in his hands a sharp sickle. (17) And another angel came out of the temple which is in heaven, he also having a sharp sickle.*

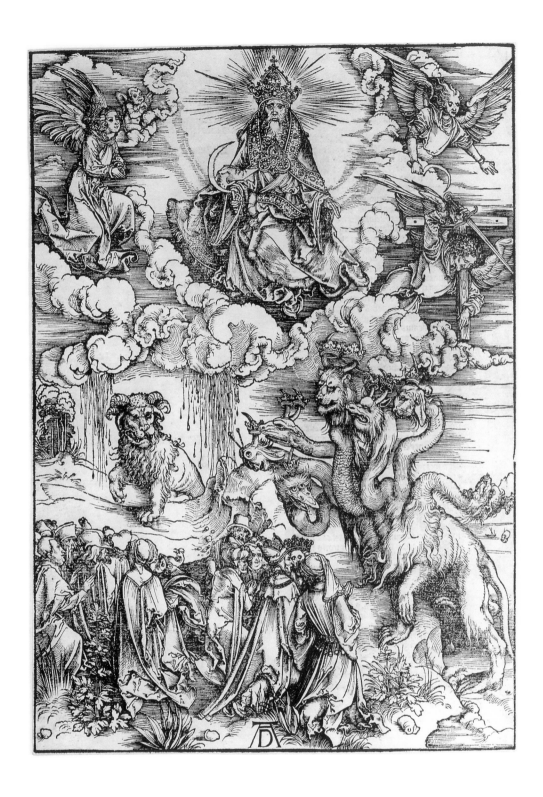

ALBRECHT DURER
Nuremberg 1471-1528 Nuremberg

20. *The Apocalyptic Woman*, 1498

Woodcut from *The Apocalypse*
390 x 276 mm.; 15 3/8 x 10 7/8 inches

References:
1. Bartsch 71
2. Meder 173
3. Hollstein 173

Notes:
1. A fine impression with full image showing, from the Latin text edition of 1511. There was a change in the Latin text of 1511 from the first lines in the Latin text edition of 1498 in the spelling of *iohannes* to *Iohannes* and of *bestiam coccinia* to *bestia cossineam*.
2. This scene is based on *Revelation* 12:

> (1) *Then there was seen a great portent in the sky, a woman clothed with the sun, and the moon beneath her feet, and upon her head a crown of twelve stars. (3) And there was seen in the sky another portent, behold, a great dragon, with seven heads and ten horns, and seven crowns upon his heads. (4) And his tail swept a third of the stars from the sky and threw them upon the earth. And the dragon stood before the woman who was about to give birth only to devour her child as soon as it was born. (5) And she bore a male child, who will rule all the nations with a rod of iron; and her child was snatched away to God and to his throne. (13) After the dragon found himself cast upon the earth, he pursued the woman who had given birth to the male child. (14) There were given to the woman the two great wings of an eagle, so that she might fly to her place in the desert, where far away from the serpent she might be nourished for an era, two eras, and half of an era. (15) Then the serpent cast from his mouth a stream of water after the woman, so that she might be swept away by the flood. (16) But the earth came to the woman's aid: and earth opened her mouth and swallowed up the stream which the dragon had cast out of his mouth.*

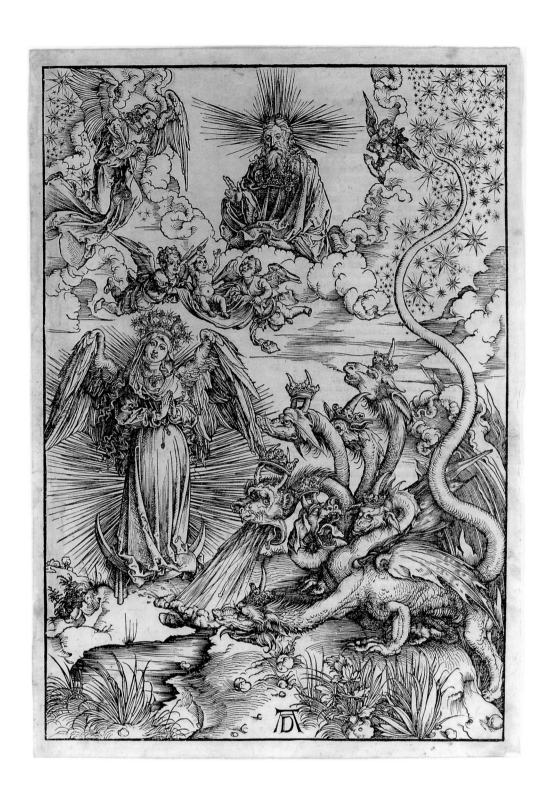

ALBRECHT DURER
Nuremberg 1471-1528 Nuremberg

21. *St. Michael Fighting the Dragon*, about 1497

Woodcut from the *Apocalypse*
392 x 283 mm.; 15 5/8 x 11 1/4 inches

References:
1. Bartsch 72
2. Meder 174
3. Hollstein 174

Notes:
1. A fine well-contrasted impression from the Latin Text edition of 1511. In this work, Dürer has eliminated many of the individual characteristics of the scenery in favor of a broad, general impression of unlimited expanse. There is a combination here, also found in another woodcut from the *Apocalypse* namely *St. John before God and the Elders*, in which there is a resplendent landscape seen below and contrasted with an extraordinary apparition in the sky.

2. The Biblical reference here is *Revelation* 12, 7-9:

> *Now war arose in heaven, Michael and his angels fighting against the dragon; and the dragon and his angels fought, but they were defeated and there was no longer any place for them in heaven. And the great dragon was thrown down; that ancient serpent, who is called the Devil and Satan, the deceiver of the whole world-he was thrown down to the earth, and his angels were thrown down with him.*

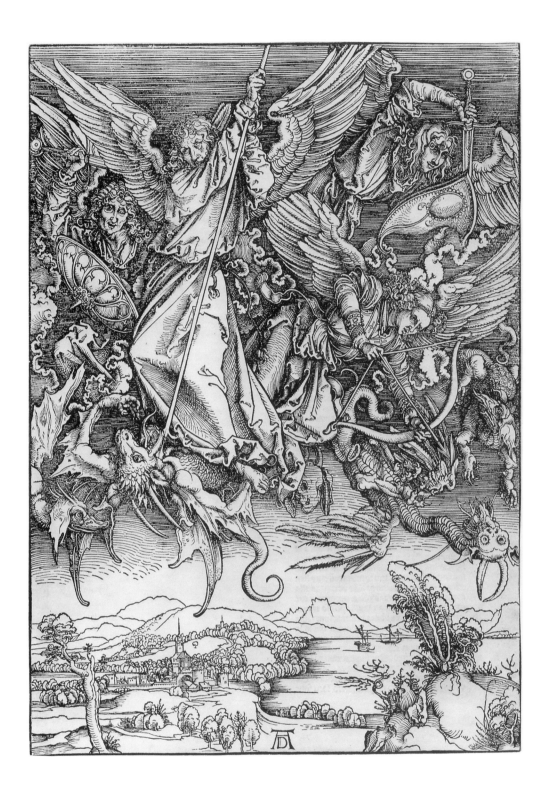

ALBRECHT DURER
Nuremberg 1471-1528 Nuremberg

22. *The Presentation of the Virgin in the Temple*, about 1503-1504

Woodcut from the *Life of the Virgin* series
296 x 210 mm.; 11 3/4 x 8 3/8 inches

References:
1. Bartsch 81
2. Meder 193

Notes:
1. A fine impression with close margins from the 1511 Latin text edition.
2. Strauss (*Albrecht Dürer: Woodcuts and WoodBlocks*, New York, 1980: p. 274) points out that Durer has taken considerable liberties in depicting this scene in which the aged parents Joachim and Anna were presenting their unexpected child Mary, then supposely only three years old. The child was to have ascended fifteen steps. In Dürer's depiction, the child is clearly older and ascends less steps. The figure above the archway has been identified by some as "Apollo the Dragon Killer": and, more probably, by others as "Mars". There are thus "pagan" motives mixed symbolically into this otherwise "religious" scene.

A LBRECHT DURER
Nuremberg 1471-1528 Nuremberg

23. *Glorification of the Virgin* (proof), about 1502

Woodcut from the Life of the Virgin series
297 x 212 mm.; 11 3/4 x 8 1/2 inches

Provenance: Duplicate from the Albertina, Vienna with its stamp (Lugt 5/d) and with the Albertina's stamp "Veraüssert" (deaccessioned)

References:
1. Bartsch 95
2. Meder 207

Watermark: *Hohe Krone* (High Crown), Meder 20

Notes:
1. A superb, early impression of this work, before the 1511 edition and typically with

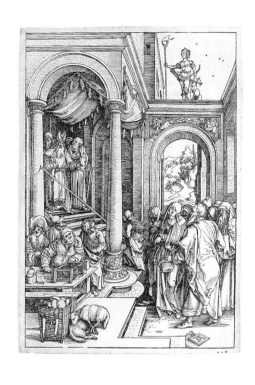

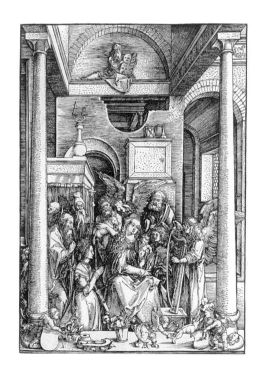

the High Crown watermark (M. 20).

2. In the bound edition of the *Life of Virgin* series, this woodcut is always placed at the end and in the Latin text edition is the only work without a text on the verso. Chronologically, however, this woodcut appears to be the earliest work from the whole series. Dürer's monogram, found on all the later examples of this series, is not found on this first work.

3. Strauss (Walter L. Strauss *Albrecht Dürer: Woodcuts and Wood Blocks*, Abaris Books, New York, 1980: p. 240) notes that the various details of this woodcut, including the winged putti playing a flute, catching a rabbit and holding a pin-wheel, a rattle and two empty escutheons, plus one of the putti holding keys signalizing the authority of the housewife, all have nothing to do with the *Life of the Virgin*. This thus appears to have been originally conceived as an independent sheet.

ALBRECHT DURER
Nuremberg 1471-1528 Nuremberg

24. *The Bag-Piper*, 1514
(*Der Dudelsackpfeifer*)

Engraving
105 x 74 mm.; 4 1/8 x 2 7/8 inches

Provenance:
GK (Unidentified collector's mark)
Gustav von Rath (Lugt 2772 and *Supplément*)

References:
Bartsch 91
Meder 90a

Notes:
1. A fine Meder a impression of this work. As usual, with early impressions, there is no watermark. Meder notes that in his following "b" impressions, there are "many vertical scratches in the sky" ("...mit vielen vertikalen Kratzern in der Luft").
2. In 1808, Bartsch already had described Durer's *The Bag-Piper* as "one of the best finished works of this artist".

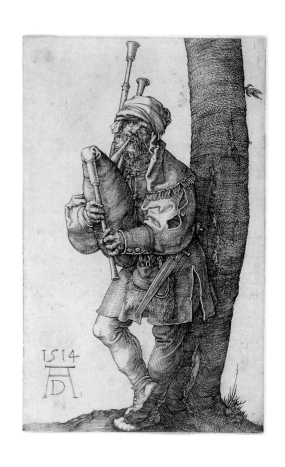

ALBRECHT DÜRER
Nuremberg 1471-1528 Nuremberg

25. *Melencolia I*, 1514

Engraving
241 x 190 mm.; 9 1/2 x 7 1/2 inches

Watermark:
Krüglein (Little Jug), Meder watermark 158

References:
1. Bartsch 74
2. Meder 75-II

Notes:
1. A very fine, early impression of the Second State of this work, one of the icons in the history of Western art. According to Meder, the *Krüglein* watermark dates this impression to 1520-25.
2. The First State of this work, with the number "9" reversed in the third row of numbers, was known by Meder in only seven impressions. The Second State of this work has the number "9" corrected. Meder had developed a series of sub-classifications of the Second State, depending on the appearance of scratches on the plate from the bat's tail through the water and a horizontal scratch on the woman's thigh. These ideas were rejected in the 1971 Boston *Dürer* catalogue (no. 189) where it is shown that these scratches are already "perfectly visible" in the First State even before the correction of the number "9". The early impressions of this work tend to be relatively lightly inked and silvery in aspect. Haussman in 1891 already had noted that: "Early impressions [of *Melencolia I*] are not as strong as those of other engravings [e.g. *Knight, Death and Devil* and *St. Jerome*] but have a rather more mellow and refined quality".
3. *Melencolia I*, along with *Knight, Death and Devil* and *St. Jerome in His Study*, is one of Dürer's three so-called "Meisterstiche" ("Master Engravings"). These three works have no apparent compositional relationship one with another but they were all executed at about the same time (1513-1514) and apparently do have a spiritual unity which various scholars including Friedrich Lippman (*Der Kupferstich*, 1893: p. 51) and Erwin Panofsky (*The Life and Art of Albrecht Dürer*, Princeton edition, 1971: p. 151) have categorized respectively as intellectual, moral and theological. Panofsky (see ref. above) sums this up:

> ...*The Knight, Death and Devil typifies the life of the Christian in the practical world of decision and action; the St. Jerome the life of the Saint in the spiritual world of sacred contemplation; and the Melencolia I the life of the secular*

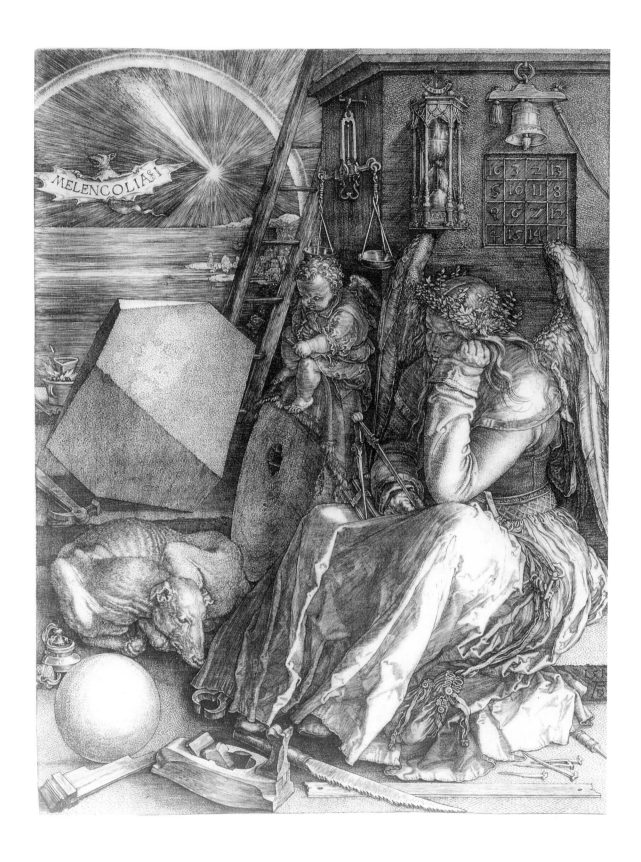

genius in the rational and imaginative worlds of science and art.

4. There is perhaps no other Dürer work which has been subject to more interpretations than *Melencolia I*. Vasari (*Lives of Artists*), in his chapter on Marcantonio Raimondi written in 1568, describes this work:

> *He then engraved several sheets on copper which astonished the entire world. One of these...pictures was Melancolia with all her instruments, which serve to describe the melancholy temperament.*

In 1675, Sandart wrote:

> *...the four lines of numbers are mysterious. Each line added across or up and down adds up to 44. This reveals the cleverness and the depth of thought of our great Dürer. [should have been "34"]*

In 1869, Heaton (p. 206) notes that:

> *Dürer meant this print to typify the insufficiency of human knowledge to attain heavenly wisdom, or to penetrate the secrets of nature. The old craving of Eve for the forbidden fruit is strong in her breast.*

In 1893, Lippmann (see ref. above) made his division (based on Gregor Reisch's *Margaritha Philosophica*, Strassburg, 1496 and 1503) of human virtues into: Virtutes intellectuales, morales, et theologicales and assigned to *Melencolia I* the "virtutes intellectuales".

In 1894, L. Cust (*The Engravings of Albrecht Dürer*, London, p. 63) wrote that:

> *The so-called magic square [of MelencoliaI] refers to the death of Dürer's mother. His mother died on May 17, 1514...[For example] the two middle figures in the top line, 3 + 2, give the month in question; and the two middle figures in the bottom line give the year, 1514. Above the square a bell tolls the fatal knell, and the sandglass timepiece hard by records no doubt the hour at which the sad event happened.*

In 1904, K. Giehlow ("Dürers Stich Melencolia I und der Maximilianische Humanisten Kreis" in *Mitteilungen der Gesellschaf fur vervielfältigende Kunst*, Vienna) wrote that *Melencolia I* was the first of a projected series of four temperaments and that the "magic square" was:

> *...A jovian talisman to counteract evil influence of Saturn, to whom the melancholy temperament is subject.*

In 1905, Heinrich Wölffin (p. 247) described this work:

A winged woman, sitting on a step near a wall, quite low, near the ground; leaden, as if she had no intention of soon getting up again. Morbid, displeased, almost frozen; only her eyes wander; but everything else is alive: a chaos of objects, all in disarray. Based on the writing of Marsilius Ficino who said that all men who excelled in the arts were melancholics...

In 1942, M.P. Perry ("Dürer's Melencolia- A Point of View" in *Apollo*, p. 65) came up with another series of ideas:

...This engraving is entirely a tribute to Dürer's mother. The small figure represents the soul that has become a little child in order to enter the Kingdom of heaven. The winged figure is the archangel St. Michael who is in charge of the scale in the medieval view of the Last Judgment. It is very doubtful that melancholy was the subject of this endeavor. Why give the large figure wings?...Wings are reserved only for Victory.

Panofsky (Erwin Panofsky *The Life and Art of Albrecht Dürer*, Princeton U. Press, 1971 edition, pages 160 and 164) describes Dürer's *Melencolia I* as being:

...super-awake; her fixed state is one of intent though fruitless searching. She is inactive not because she is too lazy to work but because work has become meaningless to her; her energy is paralyzed not by sleep but by thought. The mature and learned Melancholia typifies Theoretical Insight which thinks but cannot act. The ignorant infant, making meaningless scrawls on his slate...typifies Practical Skill which acts but cannot think...

Panofsky concludes that (pages 168 and 171):

Melancholics...are gifted for geometry and are bound to be melancholy because the consciousness of a sphere beyond their reach makes them suffer from a feeling of spiritual confinement and insufficiency. This is precisely what Dürer's Melancholia seems to experience. Winged, yet cowering on the ground - wreathed, yet beclouded by shadows-equipped with the tools of art and science, yet brooding in idleness, she gives the impression of a creature being reduced to despair by an awareness of insurmountable barriers which separate her from a higher realm of thought. ...Dürer's Melancholia...can invent and build and she can think...but she has no access to the metaphysical world...The influence of Dürer's Melencolia I - the first representation in which the concept of melancholy was transplanted from the plane of scientific and pseudo-scientific folklore to the level of art - extended all over the European continent and lasted for more than three centuries. [In conclusion]

Dürer himself ...was, or at least thought he was, a melancholic...He knew about "inspirations from above" and he knew the feeling of "powerlessness" and dejection...he was an artist - geometrician, and one who suffered from the very limitations of the discipline he loved...When he prepared the engraving Adam and Eve, *[1504] he had hoped to capture absolute beauty by means of a ruler and a compass. Shortly before he composed* Melencolia I, *[1514] he was forced to admit: "But what absolute beauty is, I know not. Nobody knows it except God"...Thus Dürer's most perplexing engraving is, at the same time, the objective statement of a general philosophy and the subjective confession of an individual man.*

ALBRECHT DURER
Nuremberg 1471-1528 Nuremberg

26. *A Peasant Couple at Market*, 1519

Engraving
116 x 73mm.; 4 5/8 x 2 15/16 inches

References:
Bartsch 89
Meder 89b

Notes:
1. A very good Meder b impression of this masterful engraving. Trimmed fractionally within platemark. Upper border with touches of ink. Otherwise condition fine.
2. Panofsky (*The Life and Art of Albrecht Dürer* by Erwin Panofsky, 1971 edition, p. 200) has pointed out the major change in Dürer's works in this period. To the earlier "Raphaelesque equilibrium of liveliness and solemnity", there is opposed a "Michelangelesque monumentality and gloom". In this latter category, Panofsky places the *Virgin Crowned by One Angel* and the *Virgin with the Swaddled Infant*, both of 1520, together with this 1519, *Peasant Couple* as typifying the "Michelangelesque" character of Dürer's later engravings.

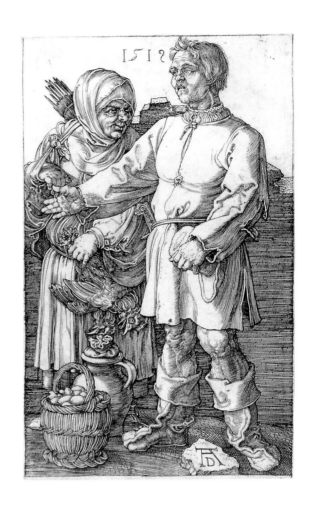

MASTER HL (Meister des Breisacher Hochaltars)

27. *Der Schmerzensmann*, 1533

Engraving
120 x 70 mm.; 4 3/4 x 2 3/4 inches

References:
Bartsch Vol. VIV p. 35, 1
TIB Vol. XIV, p. 223, 1
Nagler Mon. Vol. III, p. 47-8, 5-II

Notes:
1. A fine impression with margins and with the date of 1533.
2. At one time the Master HL had been incorrectly identified with the artist Hans Leinberger (a German sculptor active at Landshut at the beginning of the 16th century). It now is clear, as has been pointed out by Demmler, that the Master HL is the same artist who created the High Altar decoration in the church at Breisach, hence the name Meister des Breisacher Hochaltars.

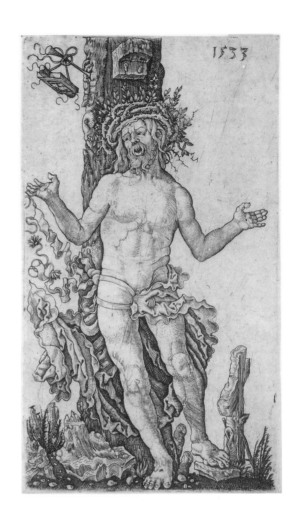

FRANCESCO MAZZOLA, IL PARMIGIANINO
Parma 1503/4 -1540 Rome

28. *The Entombment*, circa 1527-1531

Etching
310 x 238 mm.; 12 1/8 x 9 3/8 inches

Exhibited:
R.S. Johnson Fine Art *Old Master Prints and Drawings 1450-1800*, 1981, No. 33 and reproduced on p. 41.

References:
Bartsch XVI, 5-I/II
Le Blanc 2: 630, no. 6-I/II

Notes:
1. An extremely rare impression of the 1st State (of two) of this work, before the series of lines added to the right calf of Christ and before the additional lines in lower part of Christ's arm. This impression, with repairs in upper right area, has the full plateline above and on both sides, though lacking the lower blank area in no way touching the image. Compared to the Art Institute of Chicago impression of this work, this present impression is somewhat stronger and, as noted, shows the exterior image-line to the left and right as well as above, all trimmed away in the Art Institute's otherwise fine impression. This is one of the earliest, major manifestations of mannerist printmaking.
2. In the British Museum (1946-4-13-206), there is an interesting preparatory drawing for the bearded figure of St. Joseph of Arimathaea in this etching. See: Nicholas Turner *The Study of Italian Drawings: The Contribution of Philip Pouncy*, London, 1994: no. 46 and illustrated on p. 44 as pl. 46.
3. This is one of two versions of this subject by Parmigianino. Konrad Oberhuber considered this one to be a copy by Parmigianino himself of the other and what Oberhuber feels is the earlier version. It is in fact impossible to be certain which of the two versions is the first executed.
4. The story of this scene is described in all four gospels: *Matthew* 27.57-60; *Mark* 15.42-47; *Luke* 23.50-56; and *John* 19.38-42. These texts describe how, after his death, Christ's body was placed in a tomb.

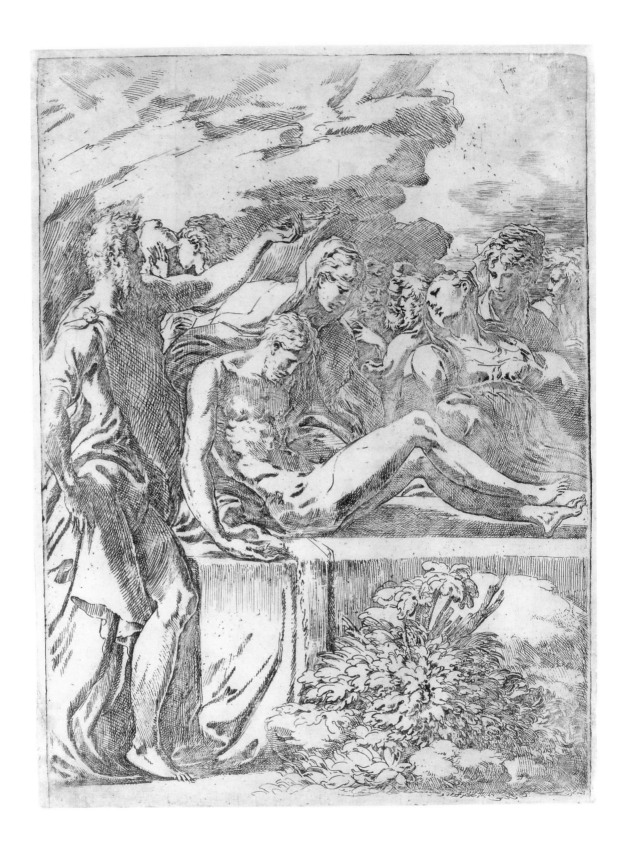

ANTONIO DA TRENTO
Bologna about 1510-1550 Bologna

29. *Madonna and Child with Rose*
(After Parmigianino)

Clair-obscur woodcut in two colors: olive green and black
190 x 232 mm.; 7 1/2 x 9 1/16 inches

References:
Bartsch XII, 12
The Illustrated Bartsch 48(12), III, 12

Notes:
1. A fine impression of this work with its usual irregularities caused by the printing blocks.
2. Along with Ugo da Carpi (about 1480-1532) and Nicolo Vicentino (active 1540-1550), Antonio da Trento was one of the great early mannerist masters of the clair-obscure woodcut. These artists were the major precursors of the later woodcuts of Hendrik Goltzius (1558-1617) and his circle of northern artists as well as later Italian artists such as Giuseppe Scolari (about 1550-1600).

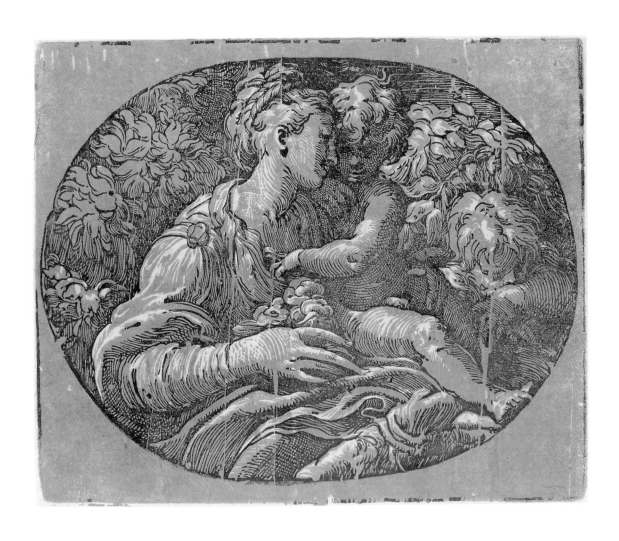

GEORG PENCZ
Nuremberg 1500-1550 Nuremberg

30. *Triumph of Love*

Engraving: Plate 1 of *The Triumph of Petrarca* suite
137 x 204 mm.; 5 3/8 x 8 inches

Provenances:
Von Nagler collection (Lugt 2529)
Duplicate from the Berlin Kupferstichkabinett (Lugt 1606)
Friedrich Quiring (Lugt 1041b)

Reference:
Hollstein 98

Notes:
A fine, beautifully nuanced impression. The collectors' marks on the verso are notable. Karl Ferdinand Friedrich von Nagler (1770-1846) was a diplomat and General Postmaster whose wide travels allowed him to bring together a group of what Lugt calls "precieuses" prints and other art works. Von Nagler's print collection was one of the four principal sources cited by Lugt as the basis for the Berlin collection brought together by King Friedrich Wilhelm III (1797-1840). After having been sold as a duplicate by the Berlin Kupferstichkabinett, this work was acquired by the Berlin collector Friedrich Quiring (born 1886) who developed an extraordinary ensemble of fine prints by Altdorfer, Dürer, Rembrandt, Van Ostade and others.

NICOLAS BEATRIZET
Lunéville c. 1520-1570 probably Rome

31. *Henri II, King of France* (1st State), 1556

Engraving
488 x 324 mm.; 19 1/4 x 12 3/4 inches

Watermark: Indistinct watermark with circle

References:
1. Bartsch 3-I/II
2. Robert-Dumesnil 40

Notes:

(description follows on next text page)

H. Mauperche f.... Auec preuillege du Roy et se vend Chez P. Sossart a Limage S.te Therese.

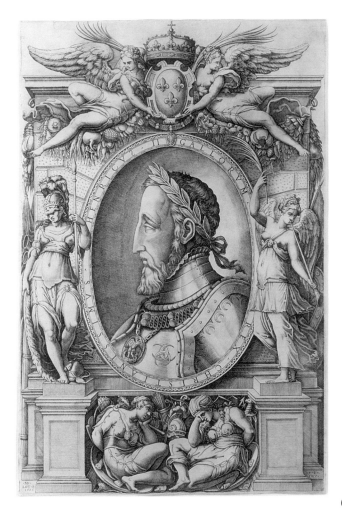

1. A very fine, impression of the 1st State (of two), with rich contrasts and with margins, of the portrait of Henri II (1519-1559).
2. Beatrizet, born in Lorrain, spent most of his life in Rome. Besides works after antique and contemporary subjects, Beatrizet did many engravings after Raphael, including his famous *Archers* after Michelangelo's drawing now at Windsor.

JUSTE DE JUSTE
Tours 1505-1559 Tours

32. *Pyramid of Six Men*, about 1543

Etching
270 x 204 mm.; 10 5/8 x 8 inches

Watermark: *Hirsch* (Stag)

Reference: Zerner J-4

Notes:
1. A fine impression but with the usual printing irregularities found in all of Juste de Juste's etchings.
2. This is one of a group of five etchings by Juste de Juste depicting pyramids of men. According to Zerner (Henri Zerner *The School of Fontainebleau*, New York, 1969), these works all date from around 1543.
3. Juste de Juste was a mysterious figure. We know that he was from a family of Florentine sculptors and that he was Rosso Fiorentino's assistant at Fontainebleau. Juste de Juste's graphic works, which are extremely rare, consisted of twelve etchings of single male nudes plus the five "pyramids". Bruce Davis (*Mannerist Prints: International Style in the Sixteenth Century*, Los Angeles County Museum, 1988: p. 195) has pointed out that: "Juste's extraordinarily free and casual manner of etching is remarkable even for the school of Fontainebleau with its exponents of an open style of modeling like Antonio Fantuzzi and Jean Mignon."
4. Often in Juste de Juste's etchings, there is a rather curious monogram found with all the letters of the artist's name. It has been noted, however, that these same letters also could be seen as spelling out the name of another engraver, Jehan Viset, who also was present at Fountainebleau at this time. This idea has been rejected by Zerner (ref. above p. XXXIV). Nevertheless there still remains a question of the identity of the author of these etchings now assigned to Juste de Juste (see: *L'Ecole de Fontainebleau* Grand Palais, Paris, 1972: p. 289).

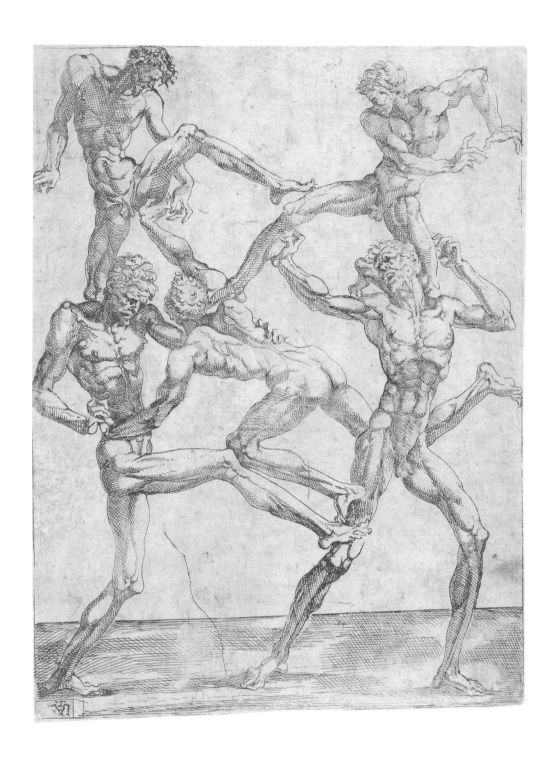

PHILIP GALLE
Haarlem 1537-1612 Antwerp

33. *The Marriage of Samson* (1st State)

Round engraving after Marten van Heemskerk (1498-1574)
258 mm.; 10 1/4 inches in diameter

References:
Kerrich S. 19,3
Hollstein 35-I/II
Hind (after M. van Heemskerck) 226-I/II

Notes:
Brilliant, very contrasted, early proof with wide margins. With the address of Hieronymous Cock but before the address of T. A. Galle, as found in the 2nd State.

PHILIP GALLE
Haarlem 1537-1612 Antwerp

34. *Samson Fighting with Lion* (1st State)

Round engraving after Marten van Heemskerck (1498-1574)
258 mm.; 10 1/4 inches in diameter

References:
Kerrich S. 19.2
Hollstein 34-I/II
Hind (after M.van Heenskerck) 225-I/II

Notes:
Brilliant, very contrasted, early proof with wide margins. With the address of Hieronymous Cock but before the address of Th. Galle, as found in the 2nd State.

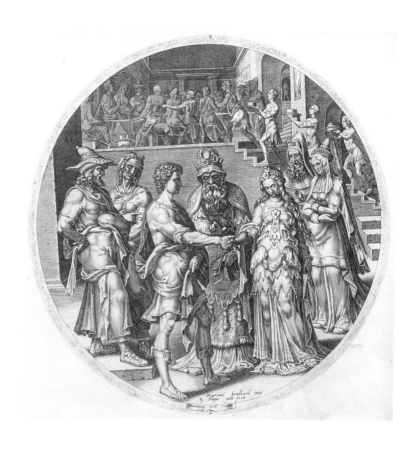

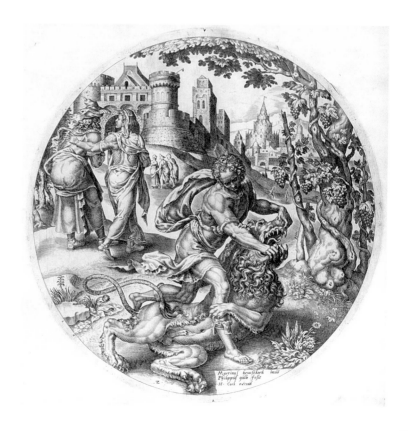

HENDRIK GOLTZIUS
Muhlbrecht bei Venlo 1558-1617 Haarlem

35. *Apollo* , 1588

Engraving in oval
346 x 258 mm.; 13 3/4 x 10 1/4 inches

Provenance:
Stamp of the Fürstlich Hohenzollersches Museum, Sigmaringen (Lugt 2759)

References:
Bartsch 141
Hirschmann/Hollstein 131
Strauss 263

Notes:
A very fine impression of this major engraving. The inscription around Apollo's head describes him as the god of sun and light who eradicates darkness on the earth. Strauss (Walter L. Strauss *Hendrik Goltzius: The Complete Engravings and Woodcuts*, New York, 1977: p. 456) sees this work, executed when the artist was thirty years old, as "an idealistic self-assessment".

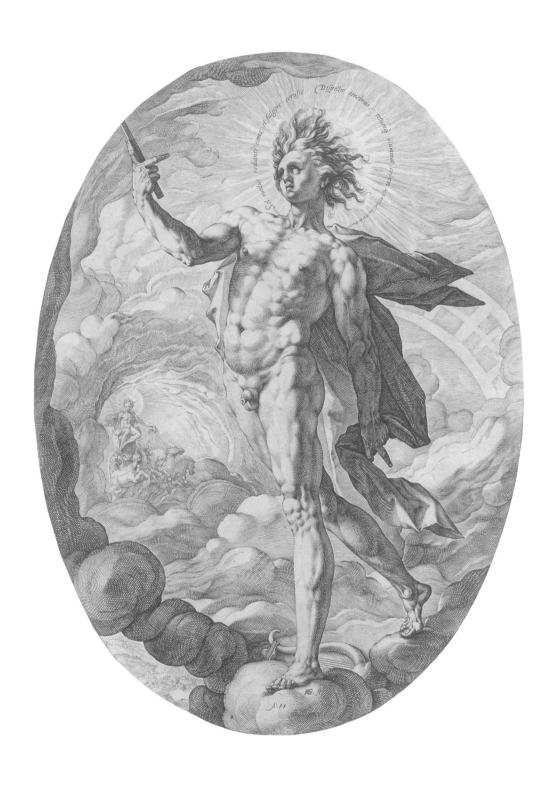

HENDRIK GOLTZIUS
Muhlbrecht bei Venlo 1558-1617 Haarlem

36. *The Adoration of the Shepherds* (2nd State), c. 1600

Engraving
199 x 146 mm.; 8 x 5 7/8 inches

References:
Bartsch 21
Hollstein 15
Strauss 362-II or III/V

Provenance:
Friedrich August II (Lugt 971)
Kupferstichkabinett, Dresden (duplicate stamp, quite similar to Lugt 685)
H.E. ten Cate (Lugt 533b)

Notes:
1. A fine impression of the rare 2nd State (of five states) of this major work. Trimmed just inside platemark, left, right and above. Strauss, in his state listings, would have this impression as either a 2nd or 3rd State. In his text, however, he writes that there is added the date of 1615 in the 3rd State. This thus would appear to be a 2nd State, before the added date.
2. From the collector's marks on this impression, there is to be noted Friedrich August II (1797-1854) from Dresden who became the King of Saxony. He began forming his famous collection of prints and drawings around 1815 when he was only eighteen years old. Starting to collect portrait engravings by Nanteuil, Edelinck, and the Drevets, he gradually moved towards Dürer, Lucas van Leyden, Marcantonio Raimondi and finally the later Dutch and Flemish etchers.

HENDRIK GOLTZIUS
Muhlbrecht bei Venlo 1558-1617 Haarlem

37. *Apollo of Belvedere*, 1580

Engraving
416 x 301 mm.; 16 3/8 x 12 inches

Watermark:
Crowned Coat of Arms with Fleur-de-lys
(Briquet 7210, dated about 1590)

(description follows on next text page)

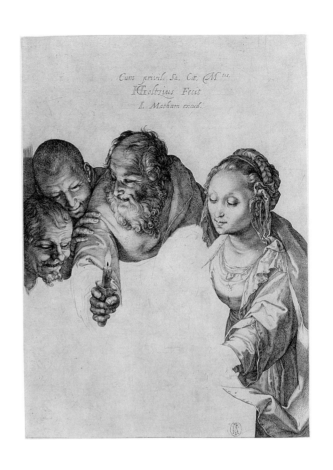

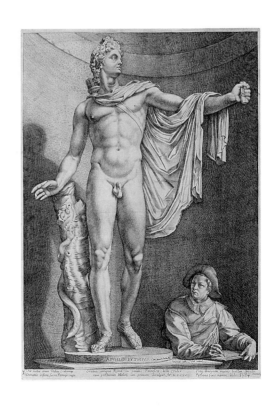

References:
Bartsch 145
Hollstein 147
Strauss 314-I/II

Notes:
A very fine impression of this rare work.

JAN HARMENSZ MULLER
Amsterdam 1571-1628 Amsterdam

38. *Arion on a Dolphin* (1st State), about 1590

Engraving after Cornelis Cornelisz van Haarlem (1562-1638)
353 x 353 mm.; 13 7/8 x 13 7/8 inches

Watermark: *Crozier of Basle*

Reference:
1. Bartsch 32
2. Hollstein 48-I/III

Notes:
1. A fine, early impression of this major work. With a *Crozier of Basel* watermark.
2. Following the lead of Goltzius, who had engraved five prints after Cornelis Cornelisz van Haarlem in 1588, Muller himself around 1590 engraved six works after Cornelisz. At least two of these works, this one and *The Three Fates*, were published by Muller's father, Harmen Muller (1540-1617). Jan Piet Filedt Kok (see: "Jan Harmensz Muller as Printmaker-I", *Print Quarterly*, September, 1994; pp. 230-231) has pointed out that *Arion on a Dolphin* had been commissioned by the Amsterdam poet Hendrik Laurensz Spieghel (1549-1612). This print in fact bears Spieghel's motto "Deuge Verheugt" (Virtue Gives Delight). According to Kok: "For Spieghel, Arion represented the ideal man, a figure with whom the poet willingly identified himself".
3. In his footnote 27, p.230, *Print Quarterly*, Sept. 1994 (see ref. above), Kok notes that the key words of Horace's poem "in se ipso totus rotundus" (*Serm.* II/7,83-86) are found according to Van Thiel (P.J.J. van Thiel "H.L. Spiegel en het orgel van Euterpe: een Hertspiegelprobleem", *Album Amicorum J.G. Van Gelder*, The Hague, 1973: ppl 312-20) in the virtuoso-like engraved circles that compose the cloud above Arion's head...".

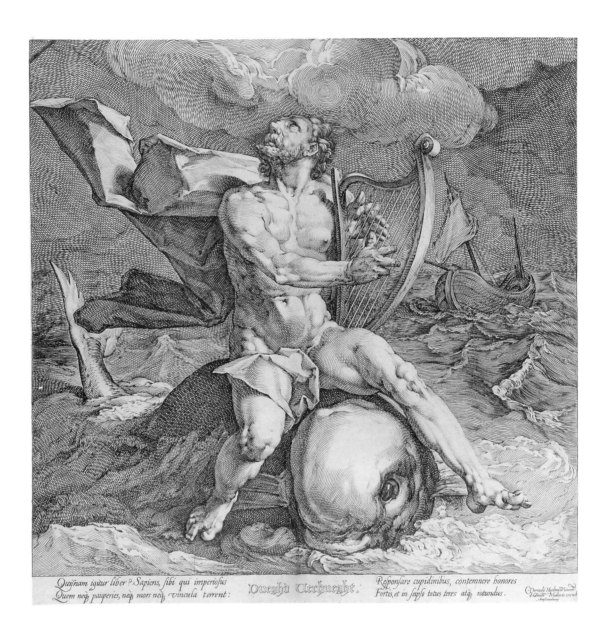

Quisnam igitur liber? Sapiens, sibi qui imperiosus Responsare cupidinibus, contemnere honores
Quem neq; pauperies, neq; mors neq; vincula terrent: Fortis, et in seipso totus teres atq; rotundus.

Oueult Terhueght.

C Cornelio Haerlemensis inuentor
H Goltzius Muller excudit
Amstelrodami

JAN HARMENSZ MULLER
Amsterdam 1571-1628 Amsterdam

39. *Bellona Leading the Armies of the Emperor Against the Turks,* (1st State), (after Bartholomeus Spranger), 1600

Engraving
515 x 368 mm.; 27 3/4 x 20 inches

Reference:
1. Bartsch 87
2. Hollstein 50

Notes:
1. Jan Harmensz Muller at first followed in the footsteps of Hendrik Goltzius but then gradually evolved into Goltzius' chief rival. Most of Muller's engraved works were after either Cornelisz van Haarlem or Bartholomeus Spranger.
2. The subject of this engraving *Bellona Leading the Armies of Emperor Against the Turks* had been preceded by another engraving *The Arts in Flight from the Barbarians* which already was an indictment of the lack of civilization of the Turks who had conquered the Greeks. In this engraving, Bellona leads not only the Emperor's armies but also civilization itself against the onslaught of the barbarians (see: Larry Silver "Imitation & Emulation: Goltzius as Evolutionary Reproductive Engraver" in *Graven Images: The Rise of Professional Printmakers in Antwerp and Haarlem 1540-1640*, Northwestern University, 1993: pages 86 and 88).

CRISPIN DE PASSE
Armuyden in Zeeland 1564-1637
probably in Holland

40. *November* (from the *Months of the Year*)

Engraving after Maarten de Vos (1532-1603)
120 mm.; 4 3/4 inches in diameter

Reference: Hollstein 587

Notes:
A fine impression.

CRISPIN DE PASSE
Armuyden in Zeeland 1564-1637
probably in Holland

41. *December* (from the *Months of the Year*)

Engraving after Maarten de Vos (1532-1603)
120 mm.; 4 3/4 inches in diameter

Reference: Hollstein 588

Notes:
A fine impression.

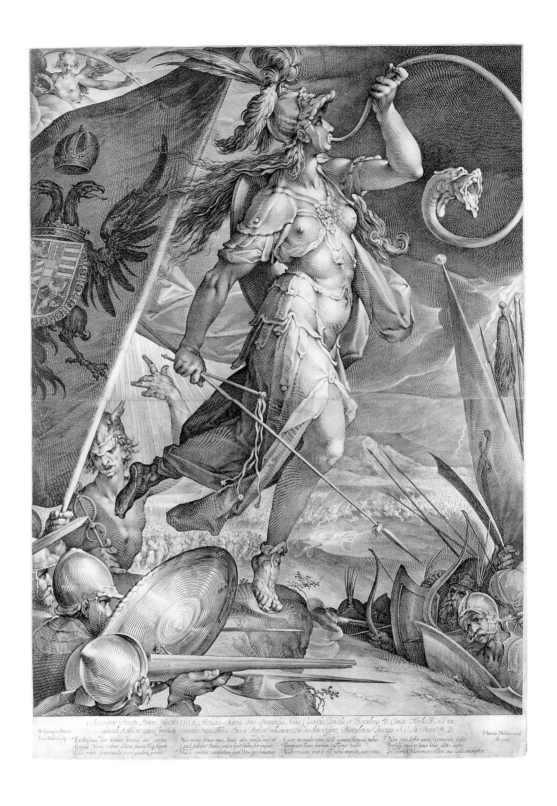

JACQUES CALLOT
Nancy 1592-1635 Nancy

42. *Louis de Lorraine, Prince de Phalsbourg*

Etching
286 x 337 mm.; 11 1/4 x 13 3/8 inches

Watermark:
Star and Lion (Lieure watermark 38)

Reference:
Lieure 505
Russell 175

Notes:
1. A very fine, early impression, with the background details as well as the head of the Prince particularly strong and clear though with traces of a center fold. Lieure indicated that the *Star and Lion* watermark is most typically found on the rare, early impressions of this work. Wide margins measuring from 35 to 46 mm. One of Callot's major prints.
2. Russell (H. Diane Russell *Jacques Callot: Prints & Related Drawings*, National Gallery of Art, Washington, D.C., 1975: p. 220) has pointed out that the plate of this work no longer is extant and, in addition, that Callot did not print many impressions. Thus, this work, particularly in very fine impressions such as this one, is quite rare.
3. Louis de Lorraine-Guise, the Prince de Phalsbourgh (the natural son of Cardinal Louis de Guise, assassinated in Blois in 1588) was one of the most important political personalities during the reign of Henri II (1606-1624). The problem of the time concerned the succession of Henri II. This was solved by the marriage of Nicole, the elder daughter of the Duke, to Charles de Vaudemont. In order to compensate Louis de Lorraine Guise for this set-back, he then was given Henriette, the daughter of Francois de Vaudemont who was the brother of Henri II. Callot's beautiful rendering of the Prince de Phalsbourg appears to have been executed in 1624 rather than 1621 as indicated by Russell (see: *Jacques Callot* Musée historique lorrain, Nancy, 1992: p. 389).
4. There are two preparatory drawings for this work at the British Museum (Ternois 790) and at the Bibliothèque-Médiathèque de Metz-Pontiffroy (Ternois, supplément no. 14).

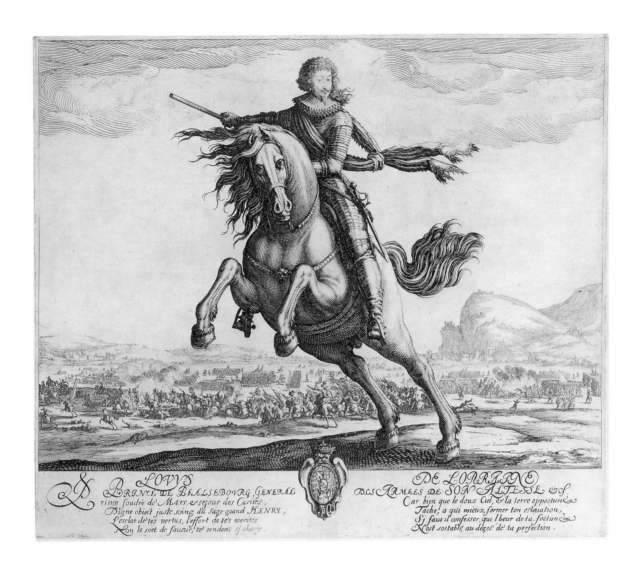

LOVYS DE LORRAINE
PRINCE DE PHALSEBOVRG, GENERAL DES ARMEES DE SON ALTESSE &c.

rince foudre de Mars, seiour des Carites, Car bien que le doux Ciel, & la terre opportune
Signe obiect iuste soing du Sage grand HENRY, Tache, a qui mieux former ton eslauation,
L'esclat de tes vertus, l'effort de tes merites Si faut il confesser, que l'heur de ta fortune
Mon le soet de sauuir, te rendent si cherry. N'est soetable au degré de ta perfection.

JACQUES CALLOT
Nancy 1592-1635 Nancy

43. *La Grande Chasse*, (1st State)
The Stag Hunt

Etching
194 x 462 mm.; 7 3/4 x 18 inches

Reference:
Lieure 353-I/IV

Notes:
1. A very fine impression of the 1st State with two birds to the left of the center tree (one was removed in the 2nd State) and with the far background clear, both characteristics of this 1st State which Lieure catalogues as "very rare" (R.R.).
2. H. Diane Russell in Jacqu*es Callot: Prints & Related Drawings*, National Gallery of Art, Washington, D.C., 1975 (p. 10) notes that "hunts were a quite common *divertimento* for aristocrats in the 16th and 17th century but also were of great interest to the general populace as seen in the hunts sometimes staged in Florence's piazzi". Callot's extraordinary contribution to this theme, as Russell sees it, was the artist's "projection of the kinetic and frenetic activity" inherent to these scenes. On the right of *The Stag Hunt*, "the swinging trees become nearly anthropomorphic participants in the hunt reinforcing the movement of the charging horses, riders, and dogs into the distant middle ground where the stag is being surrounded. At the left, huntsmen move toward the prey with a counterpoint cadence."
3. On a technical level, Russell (reference above, p. XX) notes that Callot made two great advances. One of these was the discovery of a hard ground consisting of mastic and linseed oil which, contrary to materials previously used, did not chip off plates allowing the acid to cause "foul biting". A second advance was to make an extraordinarily sensitive use of repeated bitings in order to create effects of light and space. As an example of this, Russell refers to the background area of *The Stag Hunt* which was lightly bitten before being "stopped out" with varnish. This was in sharp contrast to the deeply bitten, wide lines of the foreground.
4. Lieure (Jules Lieure *Catalogue de l'Oeuvre Gravé de Callot*, Paris, 1924-1929: Vol. II, p. 11) feels that the scene of *The Stag Hunt* took place near the city of Signa, with its very old bridge. To the left is the Hill of Artimino where the Medicis possessed a chateau with a villa constructed by Buontalenti. The river to the left, going under the little bridge in the distance, flowed into the Arno River which went through Florence.

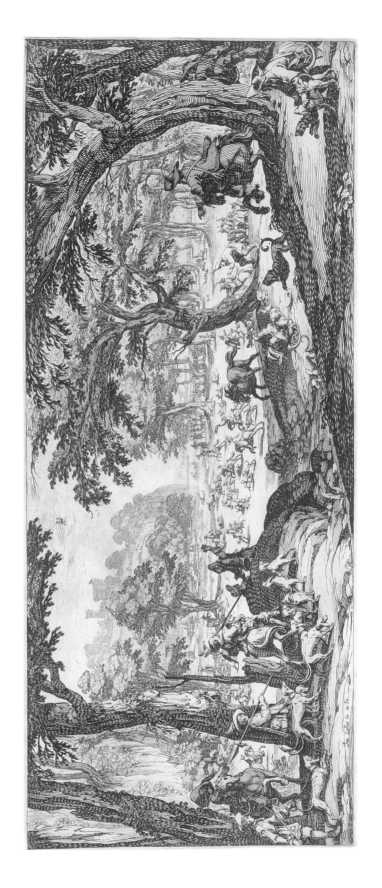

JACQUES CALLOT
Nancy 1592-1635 Nancy

44. *The Temptation of Saint Anthony* (3rd State), 1635

Etching
359 x 465 mm.; 14 1/4 x 18 5/16 inches

Reference:
1. Lieure 1416-III/V
2. H. Diane Russell *Jacques Callot: Prints & Related Drawings*, National Gallery of Art, Washington, D.C. 1975: no. 139, illustrated p. 177.
3. *Jacques Callot* Nancy, 1992: no. 494

Notes:
1. A very fine, early impression of this very major Callot. With large margins.
2. Russell (ref. above, p. 176) notes that there are three preparatory drawings for this work. She thus rejects a fourth drawing, that at the Ashmolean in Oxford, as a study for this etching and in addition is not sure that the latter drawing is even by Callot. The two drawings which are illustrated by Russell (see ref: above, nos. 137 and 138, pp. 176-178) are those at The Hermitage in St. Petersburg (ref. Ternois 954) and at the British Museum (Ternois 955).
3. In the description of the five states of this work, Lieure (*Catalogue de l'Oeuvre Gravé de Callot*) notes that in the 3rd State, one sees eleven "rosettes" or fragments thereof, below and to the right of the Coat of Arms. In the following 4th State, there is a very apparent scratch going through the wing of the first great demon, above and on the left side of this composition.
4. Mariette in about 1750 (see: ref. above, Nancy, 1992: p. 427) had described this work:

 If Callot had only executed this one work, that would have been enough for him to merit that great reputation already accorded to him. The more that one considers this admirable print, the more one discover's in it new beauties and an inexhaustible genius. It is in its way a Masterpiece of art.

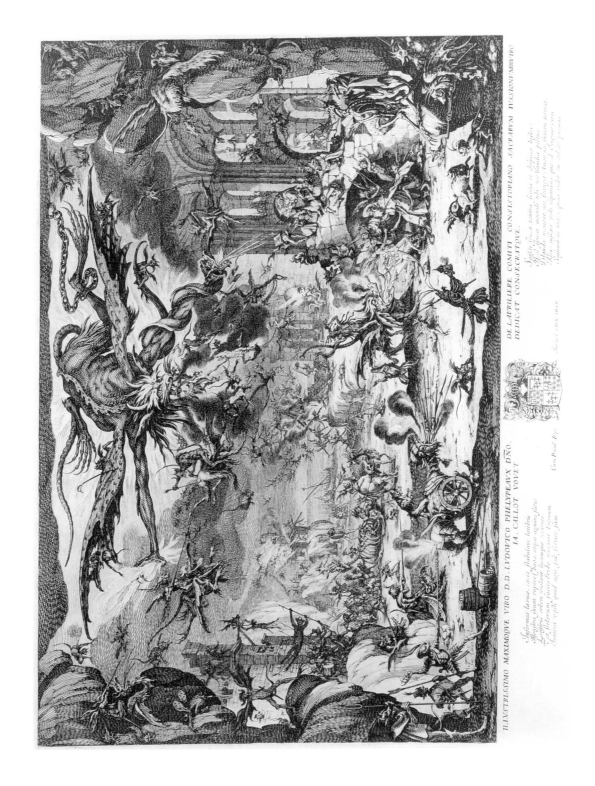

ILLVSTRISSIMO MAXIMOQVE VIRO D.D. LVDOVICO PHELYPEAVX DÑO. DE LAVRILIERE COMITI CONSISTORIANO SACRARVM INSIGNIVMVIRO
DE LA VRILIERE. IA. CALLOT VOVET DEDICAT CONSECRATQVE.

Informis larvae, cara ftabulata latibra *Smite finus tantos fuus et defunat fopho*
Horridus, filum ruptos Chaos atque aperit fata, *Fi: fpoti motule vbi nec blandus petrus*
Liderni, solem ziclant lucemque venena *Blanda monens nc fonget tuere acclinata tornat*
Et fideream, farca Erebi magnum Eremum *Afliu infoxo pole aponitur que d Corporceros*
Iterera verit quid nita fyk, fomus fiken *Innoet ac toto epus vulet in zelere propeto*

 Cum Privil Rgi. Sune cum 1608

SIR ANTHONY VAN DYCK
Antwerp 1599-1641 London

45. *Christ Crowned with Thorns* (2nd State), about 1632

Etching terminated with engraving
261 x 213 mm.; 10 1/4 x 8 3/8 inches

References:
Hollstein 20-II/VII
Manquoy-Hendrickx A-II/IX

Notes:
1. The 1st State of this work is in pure etching. The 2nd State has engraving added and in the text below, to the left, the words: "Anton van Dyck inven", and to the right. "Cum Privilegio". In the third state, after "Cum Privilegio". there was engraved: "Regis et A. Bonnefant". The additional work on this plate in the 2nd State could have been executed by Lucas Vorsteman (see: Henri Hymans *Lucas Vorsterman-Catalogue Raisonné de son Oeuvre*, Brussels, 1893: p. 40).
2. There are only two known examples of the 1st State of this work, namely those of the British Museum and of the Duke of Devonshire Collection in Chatsworth. The earliest attainable state of this work thus is the 2nd State which has become very rare.

Ecce stat innocuus spinis redemitus acutis,
Æmula sunt cuius bella labella rosis:

Et vero Iudæe illudis arundine Regi,
Impie sed nescis te mala quanta manent.

Anton. van Dyck inuen.

Cum Privilegio.

REMBRANDT HARMENSZ VAN RIJN
Leyden 1606-1669 Amsterdam

46. *Adam and Eve*, 1638

Etching
165 x 122 mm.; 6 9/16 x 4 3/4 inches
Signed and dated in the plate: *Rembrandt f. 1638*

Provenance:
Brentano-Birckenstock (Lugt 345)

Exhibited:
R.S. Johnson Fine Art *Old Master Prints 1470-1800*, Fall, 1974: No. 49 and reproduced on page 51.

References:
Bartsch 28
Gersaint 29
Hind 159-II/II

Notes:
1. A very fine impression of this major Rembrandt etching. Thread margins all around. On typically 17th century Dutch laid paper. In perfect condition.
2. The collector's mark in blue on the verso of this work, that of Brentano-Birckenstock, is one of the most prestigious for Rembrandt. Johann Melchior von Birckenstock (1738-1809), from Vienna, was a distinguished writer and diplomat. He was the personal friend of Adam Bartsch who wrote the first and now classic book on Rembrandt prints, published in Vienna in 1797. Birckenstock also was close to Duke Albert of Saxe-Teschen (who founded the present Albertina national collection in Vienna). As noted by Lugt (*Marques de collections*, p. 60), all of the sheets in Birckenstock's collection were known for their irreproachable condition. Birckenstock concentrated on etchings and his collection already had taken form by 1765. After the death of Birckenstock in 1809, this collection passed on to his daughter Antonia, born in 1780, who had married Franz Brentano (1765-1844), a professor at the University of Vienna. On the advice of Adam Bartsch, Antonia Brentano sold a good part of her collection in Vienna in 1811 and 1812. The best works, however, were kept by Mme. Brentano and were not sold until after her death in 1869. It was on these latter works (including this present etching) that there was affixed the blue collector's mark of Brentano-Birckenstock. In the catalogue of this auction; which took place in April of 1870, it is written:

Eventually the stamp of the Brentano-Birckenstock Collection will be as

precious a document as the signature of P. Mariette or the marks of the Count of Arundel or the Prince de Ligne.

3. Nowell-Usticke (*Rembrandt's Etchings: States and Values*) describe Rembrandt's *Adam and Eve* as "RR"="Rare-Very scarce", as between 50 and 75 impressions, (dating back to 1638) and finally note that the plate was destroyed. From the total number of the edition only a small percentage would have been of the quality of this particular impression.

REMBRANDT HARMENSZ VAN RIJN
Leyden 1606-1669 Amsterdam

47. *A Woman Bathing Her Feet at a Brook* , 1658

Etching and drypoint
160 x 80 mm.; 6 3/8 x 3 3/16 inches

Reference:
Bartsch 200
Hind 298 I/II

Provenance:
E. Geller (Lugt 1126).

Notes:
1. A remarkably fine, rich impression, cleanly wiped but with inky, rough plate edges, the densely worked areas of the shadows rich and black and without wear. Touches of burr on the woman's right knee and below her midriff. The Gersaint number "192" in pen and ink the lower right margin corner. With small to thread margins around the full image. In fine condition.
2. White-Boon (*Rembrandt's Etchings*, Amsterdam, 1969) note that early impressions of this work have "rough edges", such as in this one, and that such impressions in earlier catalogues are referred to as "1st State".
3. Hind distinguishes his 1st State (of two states) as being before the addition of a diagonal line 8 mm. long, added about 1 mm. below middle of top margin.
4. The collector's mark on this work is to be noted. Emil Geller (died in 1884), from Dresden, was the celebrated dealer and collector whose collection was dispersed in Leipzig in 1884-1886.

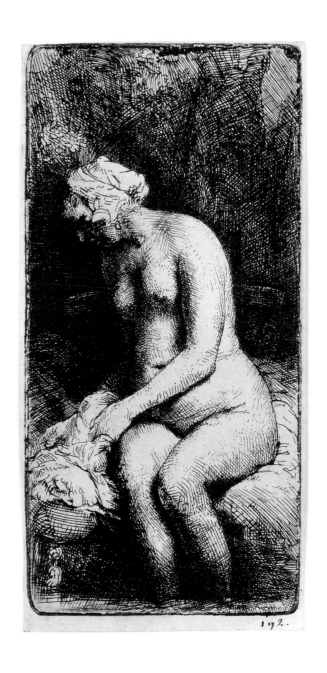

REMBRANDT HARMENSZ VAN RIJN
Leyden 1606-1669 Amsterdam

48. *Abraham's Sacrifice* 1655

Etching and drypoint
156 x 131 mm.; 6 1/8 x 5 1/4 inches

Reference:
Hollstein 35

Provenance:
T.J. Thompson (Lugt 2442).

Notes:
1. A very fine, richly inked, early impression, dark and strong and yet unusually transparent and clear in the finest details. With considerable burr throughout and printed with light tone and delicate wiping marks. With small margins.
2. This scene is described in the Old Testament, Genesis 22,1-3,9-13:

> *Later on God tested Abraham's faith and obedience. Abraham ,God called. Yes, Lord?, he replied. Take with you your only son-Yes, Isaac whom you love so much-and go to the land of Moriah and sacrifice him there as a burnt offering upon one of the mountains which I'll point out to you.*
> *When they arrived at the place where God had told Abraham to go, he built an altar and placed the wood in order, ready for the fire, and then tied Isaac and laid him on the altar over the wood. And Abraham took the knife and lifted it up to plunge it into his son, to slay him.*
> *At that moment the Angel shouted to him from heaven: Abraham, Abraham, Yes, Lord, he answered. Lay down the knife, don't hurt the lad in any way, the Angel said, for I know that God is first in your life-you have not witheld even your beloved son from me. Abraham then noticed a ram caught by its horns in a bush. So he took the ram and sacrificed it, instead of his son, as a burnt offering on the altar.*

3. The collector's mark on this work is that of T.J. Thompson (Lugt 2442). Thompson was an important, early 19th century, collector of Old Master prints. His collection was dispersed in a London auction on January 18-19, 1849 and included this impression.

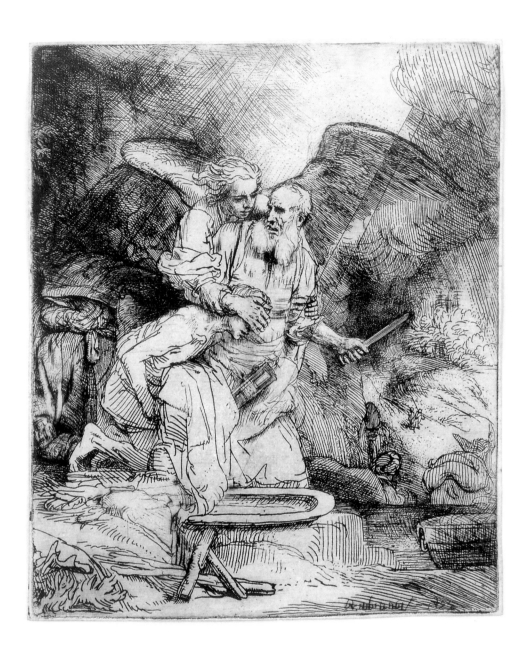

REMBRANDT HARMENSZ VAN RIJN
Leyden 1606-1669 Amsterdam

49. *Nude Man Seated before a Curtain* (1st State),1646

Etching
164 x 92 mm.; 6 3/8 x 3 3/4 inches

Watermark: *Cross and Orb,* apparently part of an *Arms of Amsterdam* watermark

Reference:
1. Bartsch/Hollstein 193-I/II
2. Hind 220-I/iI
3. Biorklund/Barnard 46-B

Notes:
1. A fine, rich impression with small margins of the 1st State (of two) of this very rare Rembrandt. Except for one margin nick and two small thin areas, upper right corner, in excellent condition. In the 2nd State, there is work added which hides the hair behind the right cheek.
2. Hind (*Rembrandt's Etchings*, New York, 1967: p.97) notes that there is a drawing-study for this etching in the Bibliothèque Nationale, Paris (repr. Michel *Rembrandt*, Paris, 1893, p.323). The etching is the reverse of this latter study.

ADRIAEN VAN OSTADE
Haarlem 1610-1685 Haarlem

50. *The Schoolmaster* (1st State), about 1644

Etching
86 x 80 mm.; 3 3/8 x 3 1/8 inches

Provenance:
1. Julius Rosenberg (Lugt 1519) with his collector's mark on verso. Rosenberg (1845-1900) of Copenhagen collected particularly 17th Century prints and, according to Lugt, possessed beautiful series of works by Rembrandt, Ostade, Claude, Everdingen, Potter, van de Velde and Zeeman,
2. R.S. Johnson Fine Art, 1974 *Old Master Prints 1470-1800*, no. 43 and reproduced on p. 44.
3. A private Midwest collection.

References:

(description follows on next text page)

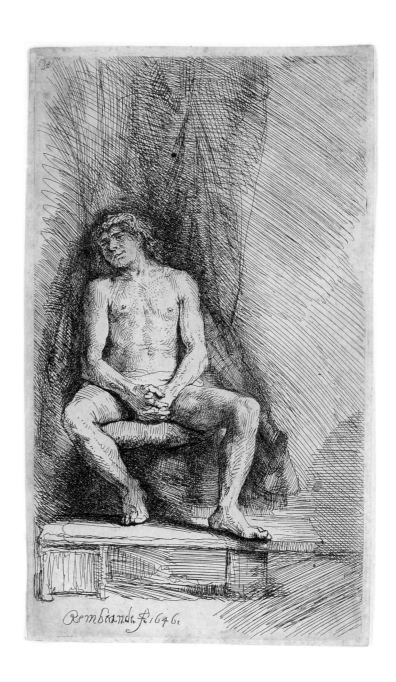

Bartsch 17
Davidson, Godefroy and Hollstein 17-I (from III).

Notes:
1. A very fine impression of the very rare 1st State of this work. Without margin but with full image. Godefroy calls this state "très rare".
2. In distinguishing the 1st State, Godefroy notes that this state is before the line, from left to right, on the hat of the schoolmaster. In the 2nd State, there also are six short, fine lines to the left of the brim of the teacher's hat and to the left of the foremost boy's forehead (on the girl's cheek).

(illustrated on page 41)

HENRI MAUPERCHE
Paris c. 1602-1686 Paris

51. *The Birth of Christ-with the Praying Shepherds*

Engraving: with the address of P. Giffart
221 x 298 mm.; 8 7/8 x 11 3/4 inches

Reference:
Robert-Dumesnil 18-II

Notes:
A very fine impression.
Mauperche was an important printmaker in his time and produced over fifty engravings.

NICOLAS CHAPRON
Chateaudun 1612-1656 Paris

52. *L'alliance de Bacchus et Venus*, 1639

Etching
314 x 392 mm.; 12 x 15 1/2 inches

Provenance: With the address of Mariette

Reference:
Robert-Dumesnil 58-III

Notes:
A strong, well contrasted impression with small margins of this intriguing subject.

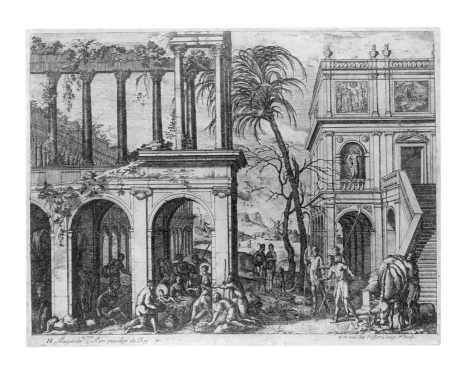

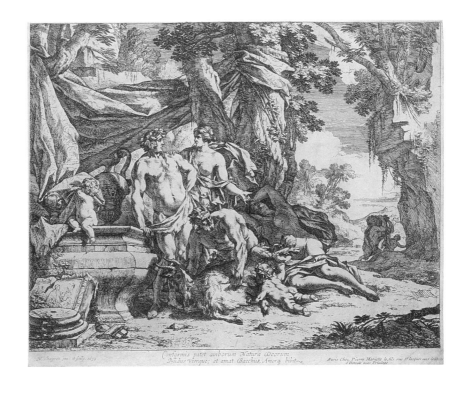

PIERRE DREVET
Loire 1663-1738 Paris

53. *Claude-Louis-Hector, duc de Villars maréchal de France*, 1715

Etching and engraving after Hyacinthe Rigaud (1659-1743)
520 x 360 mm.; 20 1/2 x 14 3/16 inches

Reference:
Firmin-Didot 123-III/IV

Notes:
1. A very fine impression of the 3rd State (of four states), with the earlier set of letters.
2. Claude-Louis-Hector, the Duke de Villars and Maréchal de France (1653-1734) was born in Moulins. He was the most effective of Louis XIV's military commanders in the War of the Spanish Succession. As a Maréchal, he won victories at Friedlingen (1702) and Höchstadt (1703). He commanded the French army in the Moselle in 1705-1706 where he stopped the Duke of Morborough from advancing into France and then also pacified the Cévennes region which had been troubled by the religious struggles of the *camisards*. At Malplaquet, while resisting valiently, the Duke de Villars was wounded (1709) but went on to save France at the battle of Denain in 1712. It was the Duke de Villars who himself then negotiated the Peace of Rastatt with Austria.
3. Drevet was one of the great French portrait engravers of his times. He was named Engraver for the King in 1696. Some of his most famous portrait engravings include *Louis XIV, Standing in His Royal Mantle* after Rigaud well as this present work, also after Rigaud, of the Duke de Villars.

LOUIS HECTOR DUC DE VILLARS

SEBASTIEN LE CLERC the ELDER
Metz 1637-1714 Paris

54. *Reduction de la Ville de Marsal en Lorraine par le roy Louis XIV L'An 1663*
The Defeat by the King Louis XIV of the City of Marsal in Lorrain in 1663

Engraving
382 x 545 mm.; 15 x 21 1/2 inches

Reference: M. Préaud No. 617

Notes:
1. This engraving is after the *Fifth Tapestry of The Great Conquest*s, after Charles Le Brun (1619-1690).
2. It was on the advice of Charles Le Brun that Leclerc decided to devote his talents to engraving. Eugene Rouir (*La Gravure Originale au XVII e Siècle, Paris*, 1974, p. 49) accords more importance to Sebastien Leclerc the Elder than to many of his direct predecessors. For Rouir, Le Clerc "posesses more force than Silvestre, more of the spiritual than Bosse and as much clarity as Callot."
3. A fine impression. Backed and with tiny nicks along the lower margin edges.

SEBASTIEN LE CLERC the ELDER
Metz 1637-1714 Paris

55. *La Passion du Christ*

The complete suite of 36 engravings
Each: 60 x 90 mm.; 2 3/8 x 3 1/2 inches

Reference: M. Préaud Nos. 201-236

Notes:
1. Superb impressions of the rare complete suite of these engravings. Each with margins outside the full plate-lines.
2. As the frontispiece of this suite indicates, these engravings were to be "presentées à Madame La Marquise de Maintenon" by her "trés humble et très obéissant serviteur Seb. Le Clerc".

(see illustration of one on page 135)

III

GIOVANNI BATTISTA PIRANESI
Mogliano 1720-1778 Rome

A Collection of the *VIEWS OF ROME*

56. Piranesi *Views of Rome* (title page)

56. *Vedute di Roma disegnate ed incise da Giambattista Piranesi Architetto Ve...ziano,* 1748
(Views of Rome: Title Page)

Etching
404 x 550 mm.; 15 7/8 x 21 5/8 inches

Watermark:
Fleur-de-lys-in Double Circle (H. 3)

References:
Hind 1-III/V
Focillon 719

(Reproduced on preceding page)

57. *Vedute di Roma,* 1748
(Views of Rome: Frontispiece with Statue of Minerva)

Etching
498 x 631 mm.; 19 5/8 x 24 7/8 inches

Watermark:
Fleur-de-lys-in-Double-Circle (H. 3)

Reference:
Hind 2-III/VII
Focillon 787

58. *Veduta di Piazza di Spagna*, 1750
(The Piazza di Spagna)

Etching
404 x 595 mm.; 15 7/8 x 23 1/2 inches

Watermark:
Fleur-de-lys-in Double-Circle (H. 3)

References:
Hind 18-IV/VIII
Focillon 79

59. *Spaccato interno della Basilica di S. Paolo fuori delle mura, 1749*
(S. Paolo Fuori Le Mura. Interior)

Etching
427 x 610 mm.; 16 3/4 x 24 inches

Watermark:
Fleur-de-lys-in-a-Single Circle (Hind 1)

References:
Hind 7-I/VIII
Focillon 792

60. *Veduta degli Avanzi del Foro di Nerva*, 1757
(The Forum of Augustus: Erroneously Called Forum of Nerva)

Etching
400 x 612 mm.; 15 3/4 x 24 1/8 inches

Watermark:
Fleur-de-lys-in Double-Circle (H. 3)

References:
Hind 42-II or III/VII
Focillon 749

(not reproduced)

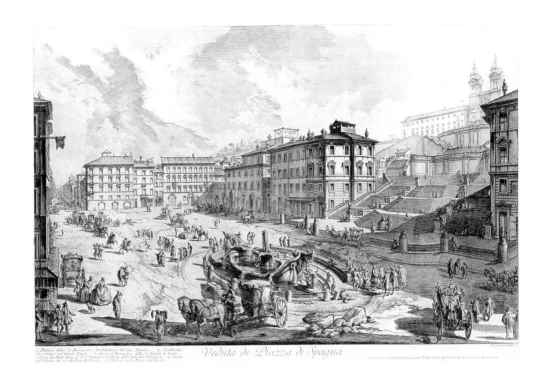

1. Fontana detta la Barcaccia, Architettura del Cav. Bernino. 2. Scalinata, che conduce sul Monte Pincio. 3. Chiesa col Monastero della SS. Trinità di Monti. *Veduta di Piazza di Spagna.* Appartiene à Monsù Piffetto nel palazzo Tomati vicino alla Trinità di monte Piccolo doi è ritratta.
Strada dei Fratti Francesi, di S. Francesco di Paolà della Nazione Francese. 4. Strada,
di Babuino, che và alla Porta del Popolo. 5. Obelisco nella Piazza del Popolo.

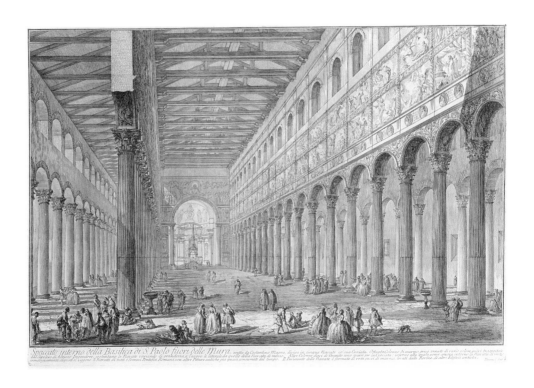

Spaccato interno della Basilica di S. Paolo fuori delle Mura, eretta da Costantino Magno, divisa in cinque Navate ed una Crociata. Ottanta colonne di marmo, assai venute di varie colonne, que è di spedita
dal Sepolcro di Adriano Imperadore, sostentano le Navate sopra, di ornamenti, e incrostata di lateriti da quelle della Basilica di mezzo. Altre Colonne dopo di Corpo sono spose per la Crociata. colonne alle quale come quasi intorno si fan che di vicino
communemente disposti a giorno. I Ritratti di tutti i Sommi Pontefici Romani con altre Pitture antiche sta quasi ornamento del Tempio. Il Pavimento delle Navate, e formato di vari pezzi di marmo, tolti dalle Rovine di altri Edificii antichi.

61. *Veduta del Pantheon d'Agrippa oggi Chiesa di S. Maria ad Martyres* 1761
The Pantheon Exterior

Etching
470 x 686 mm.; 18 1/2 x 27 1/8 inches

Watermark:
Fleur-de-lys-with Double-Circle (H. 3)

References:
Hind 60-I/V
Focillon 761

62. *Veduta del tempio della Sibilla in Tivoli*, 1761
(The Temple of the Sibyl: with another Temple at right, once used as Church of S. Giorgio)

Etching
420 x 632 mm.; 16 1/2 x 26 inches

Watermark:
Fleur-de-lys-with Double-Circle (H. 3)

References:
Hind 61-I/V
Focillon 764

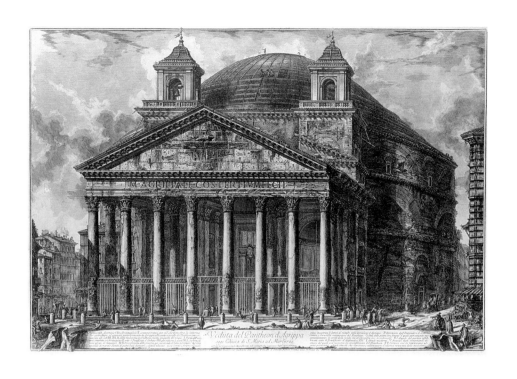

Veduta del Pantheon d'Agrippa
oggi Chiesa di S. Maria ad Martyres

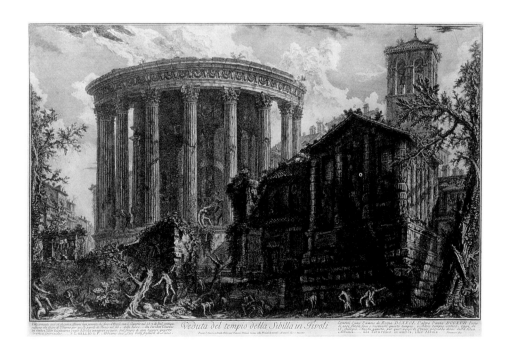

Veduta del tempio della Sibilla in Tivoli

63. *Altra Veduta del Tempio della Sibilla in Tivoli*, 1761
The Temple of the Sibyl, Tivoli: The Broken Side of the Colonnade

Etching
444 x 660 mm.; 17 1/2 x 26 inches

Watermark:
Fleur-de-lys-with Double-Circle (H. 3)

References:
Hind 62-I/III
Focillon 765

64. *Avanzi della Villa di Mecenate a Tivoli, costruita di travertini a opera incerta*, 1763
The So-Called Villa of Maecenas at Tivoli

Etching
445 x 675 mm.; 17 7/8 x 26 3/8 inches

Watermark:
Fleur-de-lys-with Double-Circle (H. 3)

References:
Hind 65-I/III
Focillon 768

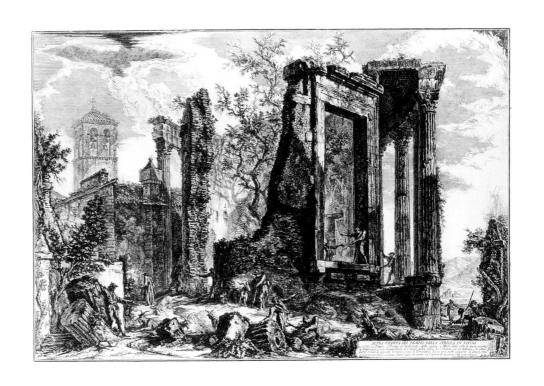

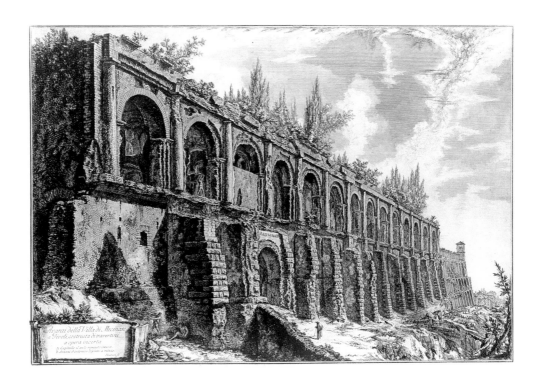

65. *Sepolcro di Cecilia Metella*, 1762
 The Tomb of Caecilia Metella

 Etching
 458 x 630 mm.; 17 7/8 x 24 7/8 inches

 Watermark:
 Fleur-de-lys-in Double Circle (H. 3)

 References:
 Hind 67-I or II/V
 Focillon 772

66. *Veduta interna della villa di Mecenate*, 1764
 The So-Called Villa of Maecenas at Tivoli: Interior, with Two Figures in the Opening of an Arch Above

 Etching
 470 x 675 mm.; 18 5/8 x 24 1/2 inches

 Watermark:
 Fleur-de-lys-in Double Circle (H. 3)

 References:
 Hind 73-I or II/IV
 Focillon 769

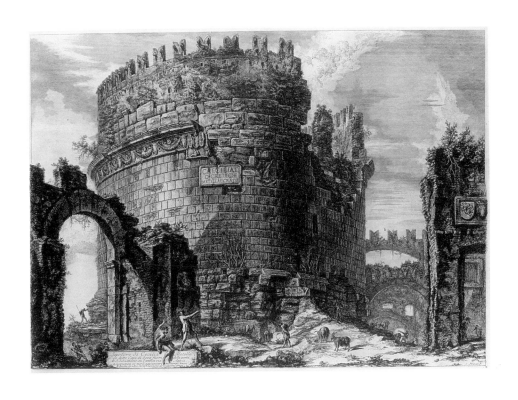

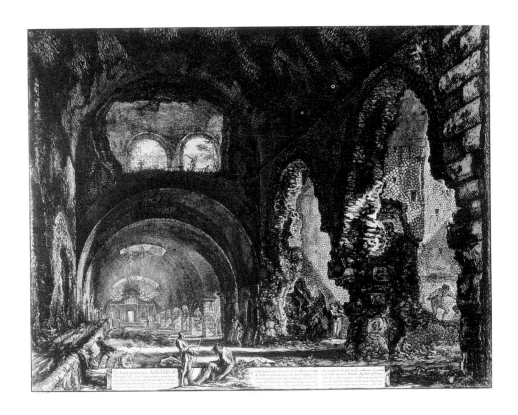

67. *Veduta del, Tempio ottangulare di Minerva Medica*, 1764
The So-Called Temple of Minerva Medica

Etching
460 x 700 mm.; 18 1/4 x 27 1/ 2 inches

Watermark:
Fleur-de-lys-with Double-Circle (H. 3)

References:
Hind 74-I or II/IV
Focillon 778

68. *Rovine delle Terme Antoniniane*, 1765
The Baths of Caracalla Bird's-Eye View

Etching
440 x 690 mm.; 17 1/4 x 27 3/8 inches

References:
Hind 76-I/III
Focillon 852

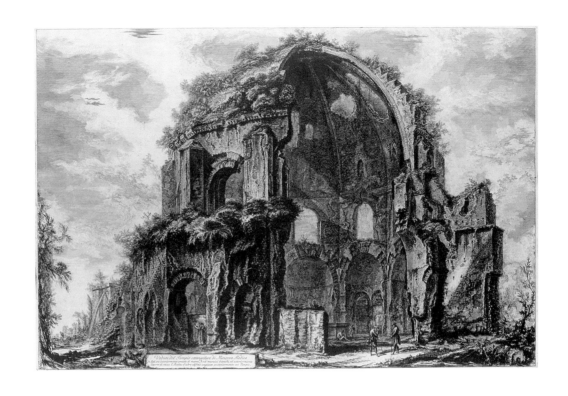

Veduta del Tempio cattogorico di Minerva Medica

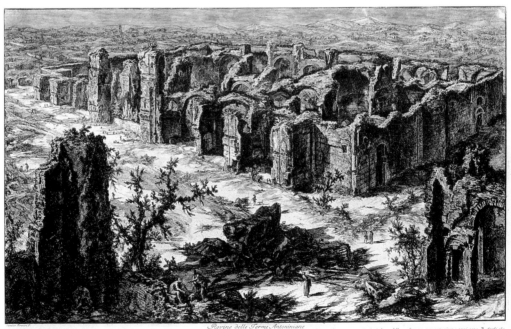

Rovine delle Terme Antoniniane

69. *Veduta della Cascata di Tivoli*, 1765
 The Waterfall at Tivoli

Etching
470 x 695 mm.; 18 5/8 x 27 5/8 inches

Watermark:
Fleur-de-lys-in-Double-Circle (H. 3)

References:
Hind 75-II/V
Focillon 779

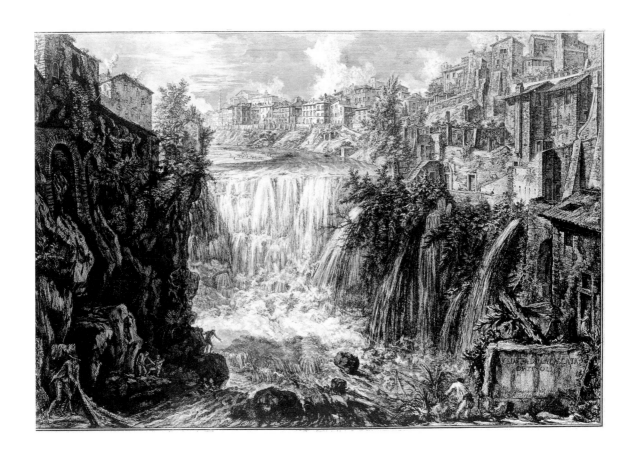

70. *Veduta dell'interno dell'Anfiteatro Flavio detto il Colosseo,* 1766
 The Colosseum: Interior

Etching
455 x 690 mm.; 18 x 27 1/4 inches

References:
Hind 78-III/V
Focillon 760

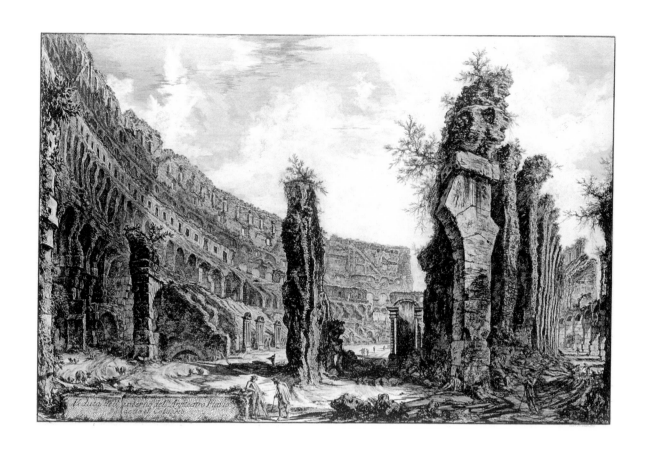

Veduta dell'interno dell'Anfiteatro Flavio detto il Colosseo

71. *Avanzi del Tempio detto di Apollo nella Villa Adriana vicino a Tivoli*, 1768
Hadrian's Villa Remains of the Smaller Palace (Formerly Called the Temple of Apollo)

Etching
470 x 620 mm. x 18 1/2 x 24 3/8 inches

Watermark:
Fleur-de-lys-in Double-Circle (H. 3)

References:
Hind 85-I/IV
Focillon 771

72. *Veduta degl'avanzi del sepolero della famiglia Plauzia sulla via Tiburtina vicino al ponte Lugano due miglia lontano da Tivoli*, 1761
The Tomb of the Plauti, near the Ponte Lucano

Etching
455 x 620 mm.; 18 1/8 x 24 1/2 inches

Watermark:
Fleur-de-lys-in-Double-Circle (H. 3)

References:
Hind 83 I/III
Focillon 783

Note:
Hind indicates a date of 1765-69 rather than 1761.

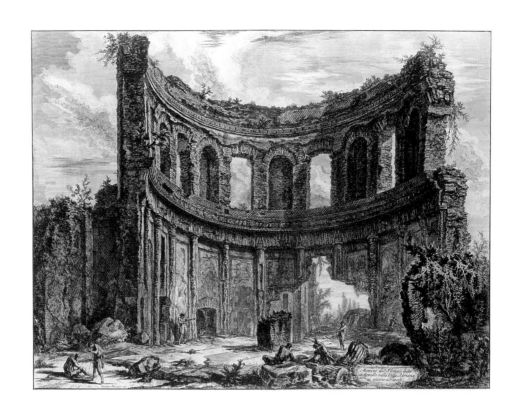

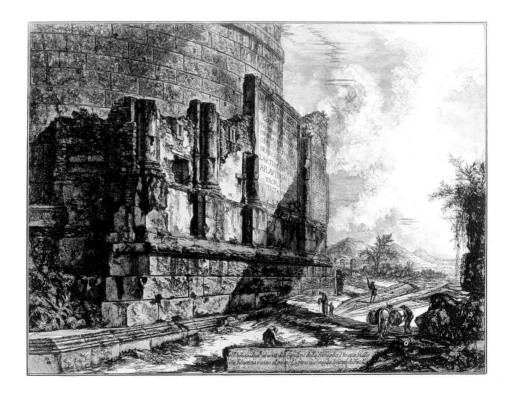

73. *Veduta delle Cascatelle a Tivoli,* 1769
The Small Waterfall and Rapids at Tivoli

Etching
470 x 705 mm.; 18 5/8 x 27 3/4 inches

Watermark:
Fleur-de-lys-in-Double-Circle (H. 3)

References:
Hind 92-I/IV
Focillon 780

74. *Rovine d'una Galleria di Statue nella Villa Adriana a Tivoli,* 1770
Hadrian's Villa: The Cental Room of the Larger Thermae

Etching
450 x 585 mm; 17 3/4 x 23 inches

Watermark:
Fleur-de-lys-in-Double-Circle (H. 3)

References:
Hind 93-I/III
Focillon 785

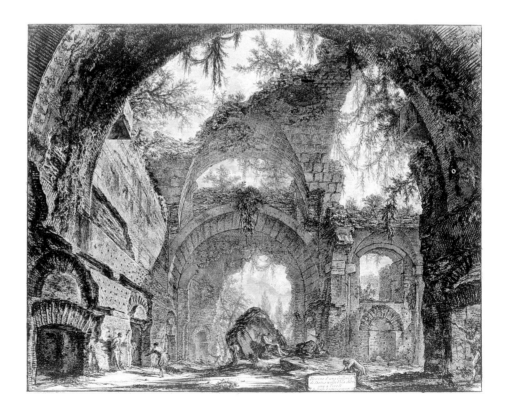

75. *Tempio detto volgarm di Giano*, 1771
 The Arch of Janus (Janus Quadrifrons) with the Arch of the Moneychangers

 Etching
 470 x 702 mm.; 18 1/2 x 27 7/8 inches

 Watermark:
 Fleur-de-lys-with Double-Circle (H. 3)

 References:
 Hind 96-I/IV
 Focillon 825

76. *Veduta dell'Arco di Costantino*, 1771
 The Arch of Constantine

 Etching
 470 x 705 mm.; 18 5/8 x 27 7/8 inches

 Watermark:
 Fleur-de-lys-with Double-Circle (H. 3)

 References:
 Hind 97-I/III
 Focillon 757

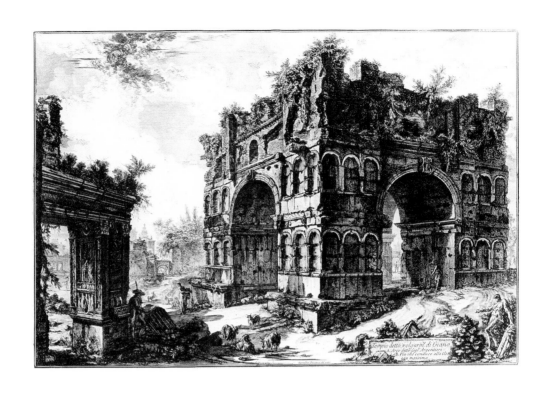

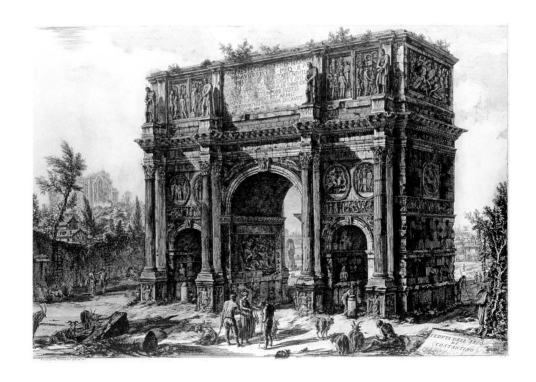

77. *Veduta dell'Arco di Tito*, 1771
The Arch of Titus with the Casino Farnese on the Left

Etching
470 x 705 mm.; 18 5/8 x 27 7/8 inches

Watermark:
Fleur-de-lys-in-Double-Circle (H. 3)

References:
Hind 98-I/IV
Focillon 755

78. *Veduta dell'Arco di Settimo Severo*, 1772
The Arch of Septimus Severus

Etching
470 x 700 mm.; 18 5/8 x 27 7/8 inches

References:
Hind 99-I/III
Focillon 754

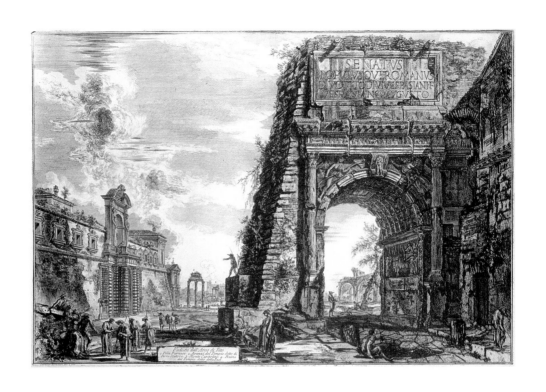

Veduta dell'Arco di Tito
1 Villa Farnese. 2 Avanzi del Tempio Sotto di
Giove Statore. 3 Monte Capitolino. 4 Rovine
del Tempio detto della Pace

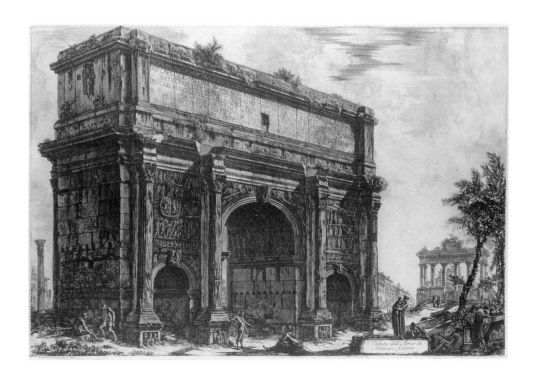

Veduta dell'Arco di
Settimio Severo

123

79. *Veduta del Tempio detto della Concordia,* 1774
The Temple of Saturn with a Corner of the Arch of Septimus Severus in the Foreground

Etching
470 x 700 mm.; 18 3/8 x 27 1/2 inches

Watermark:
Fleur-de-lys-in-Double Circle (H. 3)

References:
Hind 109-I/III
Focillon 829

80. *Altra veduta degli avanzi del Pronao del Tempio della Concordia,* 1774
The Temple of Saturn, with the Arch of Septimus Severus in the Background

Etching
460 x 695 mm.; 18 1/4 x 27 1/2 inches

Watermark:
Fleur-de-lys-in-Double Circle (H. 3)

References:
Hind 110-I/III
Focillon 830

81. *Veduta del Tempio delle Camene anticamente circon dato da un bosco nella valle di Egeria, si vede fuori di Porta Latina nella valle detta la Gaffarella,* **Temple of the Camenae (also called: Temple of Deus Rediculus),** 1773

Etching
470 x 700 mm.; 18 5/8 x 27 7.8 inches

Watermark:
Fleur-de-lys-in-Double Circle (H. 3)

References:
Hind 106-I/IV
Focillon 827

(not reproduced)

124

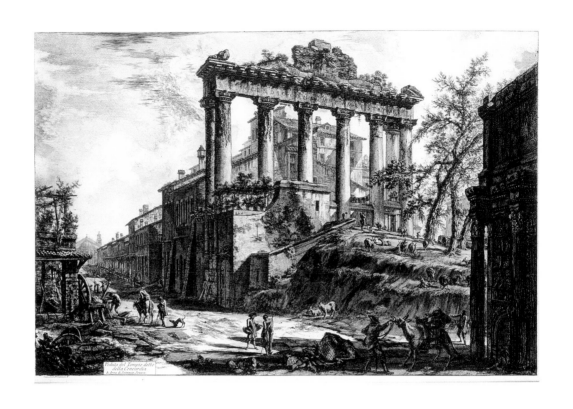

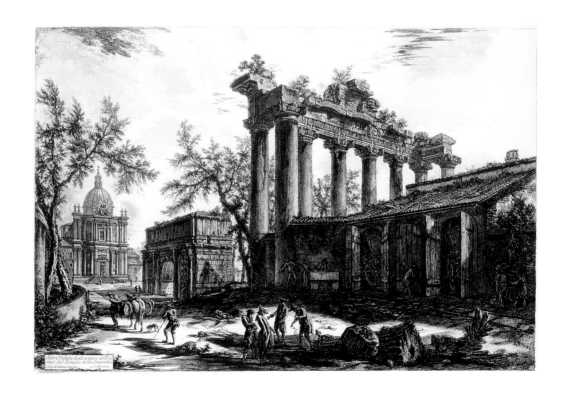

82. *Veduta di Piazza Navona sopra le rovine del Circo Agonale,,* 1773
The Temple of Saturn, with a Corner of the Arch of Septimus Severus in the Foreground,The Piazza Navona, with S. Agnese on the Left

Etching
460 x 695 mm.; 18 3/8 x 27 1/2 inches

References:
Hind 108-I/IV
Focillon 733

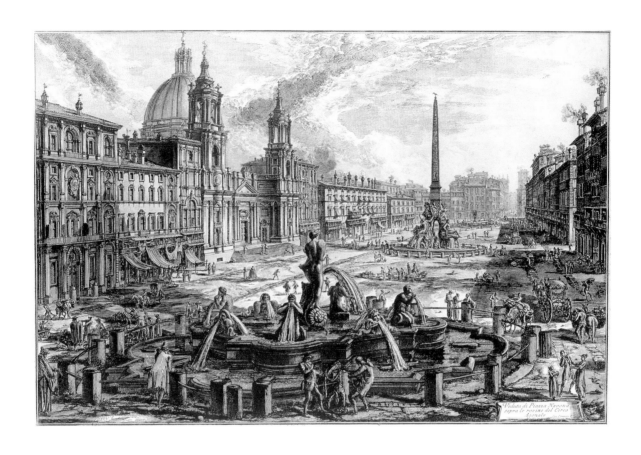

83. *Veduta degli avanzi del tablino della Casa aurea di Nerone detti volgarmente il Tempio della Pace*, 1774
The Basilica of Constantine: with a Street Seen through Arches on the Left

Etching
480 x 700 mm.; 19 x 27 3/4 inches

Watermark:
Fleur-de-lys-in-Double-Circle (H. 3)

References:
Hind 114-I/IV
Focillon 751

84. *Veduta della Piazza e Baiclica di S. Giovanni in Laterano*, 1775
The Piazza and Basilica of S. Giovanni in Laterano (side facade): With the Obelisk, Palace, and Scala Santo on Left

Etching
495 x 700 mm.; 19 1/4 x 27 1/2 inches

Watermark:
Fleur-de-lys-in-Double-Circle (H. 3)

References:
Hind 117-I/IV
Focillon 725

Note:
This is the only one of Piranesi's four views of S. Giovanni in Laterano showing the Baptistry.

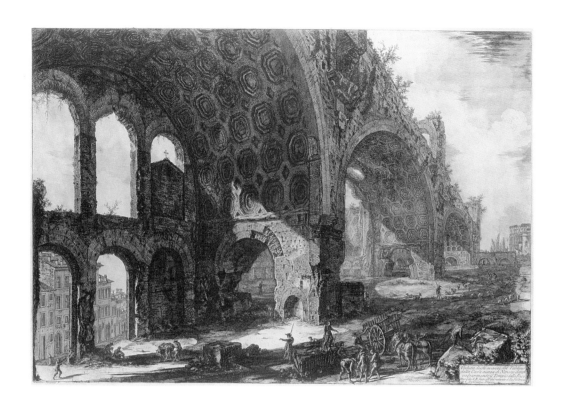

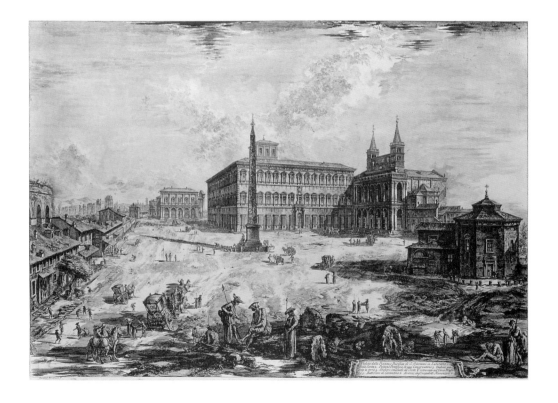

85. *Veduta del Monumento eretto dall'Imperador Tito Vespasiano per aver ristaurati gl'Aquedotti*, 1775
The Porta Maggiore, Originally an Archway of the Aqua Claudia and the Anio Novus

Etching
490 x 705 mm.; 19 1/8 x 27 5/8 inches

References:
Hind 119-I/III
Focillon 839

86. *Veduta dell'Isola Tiberina*, 1775
The Isola Tibernia, with S. Bartolomeo in the Foreground

Etching
470 x 710 mm.; 18 5/8 x 28 inches

References:
Hind 121-I/III
Focillon 836

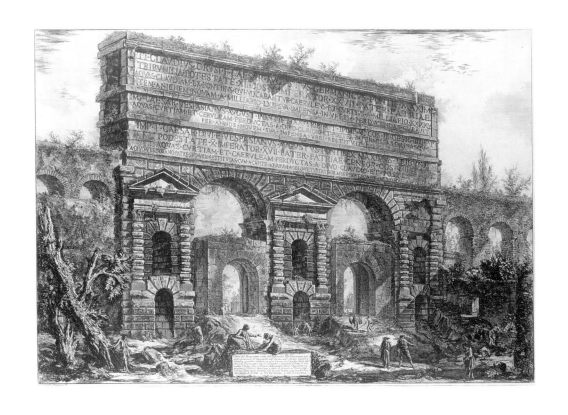

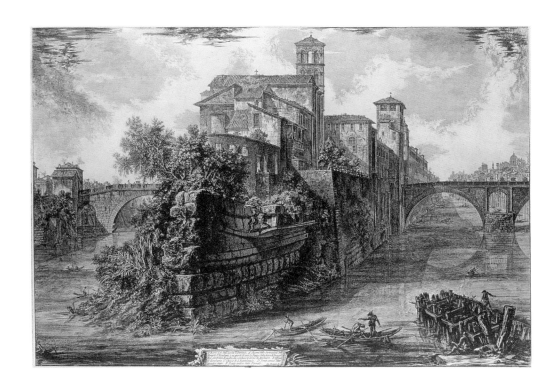

87. *Avanzi degl'Aquedotti Neroniani*, 1775
 The Aquaduct of Nero Leading to the Palatine: a Branch of the Aqua Claudia

Etching
486 x 705 mm.; 19 1/4 x 27 3/4 inches

Watermark:
Fleur-de-lys-in Double-Circle (H. 3)

References:
Hind 118-I/IV
Focillon 850

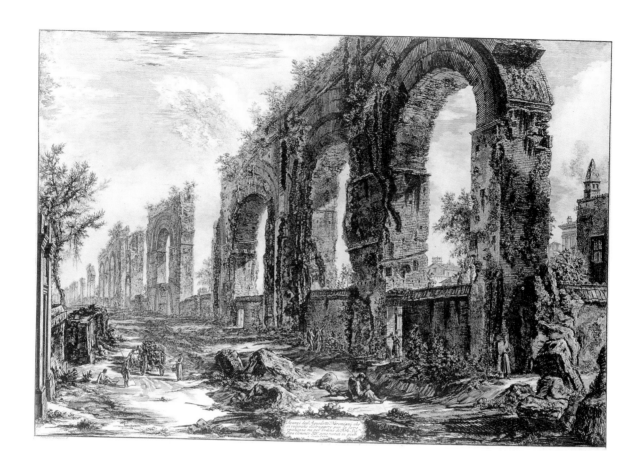

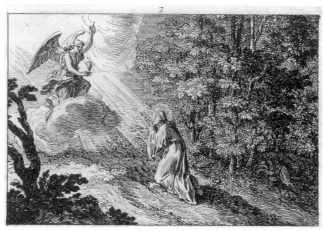

55. Le Clerc, (one of set)

INDEX